Tiata Fahodzi and Soho Theatre

present

Iya-Ile
(The First Wife)

20 years before *The Estate*

by Oladipo Agboluaje

First performance at Soho Theatre
on Thursday 14 May 2009

CREATIVE TEAM

Director/Choreographer **Femi Elufowoju, jr**
Designer **ULTZ**
Lighting Designer **Trevor Wallace**
Costume Designer **Moji Bamtefa**
Soundscape Designer/Composer **Simon McCorry**
Fight Director **Tom Lucy**
Choral Consultant **Ayo-Dele Edwards**
Assistant to the Director **Kolawole Oluwole**
Assistant to the Designer **Milja Amita Kilumanga**

Casting **Nadine Rennie**
Production Manager **Matt Noddings**
Company Stage Manager **Louise Green**
Deputy Stage Manager **Francesca Finney**
Assistant Stage Manager **Samantha Tooby**
Technical Manager **Nick Blount**
Photographer **Hugo Glendinning**
Set Builders **Factory Settings Ltd**

ACKNOWLEDGEMENTS

Tiata Fahodzi would like to thank:

Bolaji and Charles Coker (rehearsal costumes), Mosun Adesina (proprietor of Aso-Rock Restaurant, Hoxton), Abiodun Elufowoju & Cameron Roach;

Out of Joint and Almeida;

the actors who contributed to the development of *Iya-Ile*: Obi Abili, Taiwo Ajai-Lycett, Jude Akuwudike, Tobi Bakare, Babou Ceesay, Jocelyn Jee Esien, Tunji Kasim, Yetunde Oduwole, Chiké Okonkwo, Marcy Oni, Nick Oshikanlu, Stephen Ovba (Breis), Ellen Thomas;

Michelle Gilmore (stage management placement);

the Gibbs Charitable Trust;

everyone at Soho Theatre.

We would also like to recognise and give thanks for the genius of **Fela Anikulapo Kuti** and **Sunny Ade** whose music is heard throughout the production.

Iya-Ile
(The First Wife)

20 years before *The Estate*

by **Oladipo Agboluaje**

CAST *in order of appearance*
Helen **Estella Daniels**
Lomi Pakimi **Javone Prince**

Chief Olanrewaju Adeyemi **Jude Akuwudike**
Mrs Toyin Adeyemi **Antonia Okonma**

Soldier **Chucky Venn**

Afolabi **Nick Oshikanlu**
Mrs Okomile **Marcy Oni**

Soji Adeyemi **Tobi Bakare**
Yinka Adeyemi **Babatundé Aléshé**

Archbishop Billy Robertson **Chucky Venn**

Onijuju **Marcy Oni**
K.K. Folarin **Chucky Venn**

All other roles played by members of the company

Cast

Jude Akuwudike

Jude trained at RADA. His most recent work in the theatre includes *Walking Waterfall* at Tiata Delights 08 (Tiata Fahodzi/Almeida Theatre), *The Resistible Rise of Arturo Ui* at the Lyric Hammersmith, Anthony Neilson's *God in Ruins* at Soho Theatre; *Macbeth* and *Macbett* (RSC); *Our Country's Good*, *The Recruiting Officer* (Royal Court); *The Overwhelming*, *Edmond*, *Not About Nightingales* and *Henry V* (National Theatre) and *Pericles* at the Globe. Jude won a TMA award for *Poor Superman* (Traverse/Hampstead). On television, Jude most recently starred in Joe Penhall's *Moses Jones* and in *The No.1 Ladies' Detective Agency* (BBC). His long list of TV credits includes *The Last Detective*, *Silent Witness*, *Roger Roger* and *Land of Dreams*. Film includes *Whisper*, *Sahara* and *Touched by a Stranger*. Jude has also done extensive work for BBC Radio, including a long run in the World Service's *Westway*.

Babatundé Aléshé

A 2008 graduate from the Central School of Speech and Drama, Babatundé's theatre career includes *Holes* (New Wimbledon Studio Theatre), *The Dutchmen* (Hampstead Theatre), *In Time* (Tiata Fahodzi/Eastern Angles), *He Left Quietly* (Barbican Pit Theatre), *Dis Shoodbe on TV* (Hackney Empire/Catford Broadway/The Drum). Television and radio appearances encompass *Law & Order: UK* (Kudos/ITV), *New Tricks* (Wall to Wall/BBC); *Listen Against* (BBC Radio 4). Films include *Pelican Blood* (Ecosse Films), *Melvin: Chronicles of a Player* (Miles of Styles; Winner of Best Independent Film at the Screen Nation Awards). Babatundé is also an award-winning stand-up comedian, winning Best Newcomer at the BECA Awards and Da Comedy fun house (2005).

Tobi Bakare

Tobi Bakare is currently training at Identity Drama School, the UK's first Black Drama School. His theatre credits to date include: *1800 Acres* (Riverside Studios), *Gone Too Far* (Royal Court Theatre), *Mangina Monologues* (Soho Theatre), *Torn* and *Totally Over You* (both Arcola Theatre) and *Macbeth* for Out of Joint. Television credits include *The Bill* (ITV), *Holby City* (BBC), *Silent Witness* (BBC), *Meet The Bandais* (E4), *The Omid Djalili Show* (BBC) and *Dani's House* (BBC).

Estella Daniels

Since graduating from The Actor Works Drama School in 2008 Estella's theatre credits include *Treasure Island* (Theatre Royal Haymarket), *Shoot2Win* (Brockley Jack Theatre), *FESTA* (Young Vic), *The Sweetest Swing in Baseball* (Pacific Playhouse), *Teen Dreams* (Half Moon Theatre) and workshops for Tiata Fahodzi/Unicorn Theatre.

Antonia Okonma

Antonia has an extensive list of television credits culminating in *Moses Jones* (BBC) earlier this year. Her best known role is Darlene Cake in ITV's *Bad Girls* and she also made a memorable appearance in *Ultimate Force* (ITV). She trained at the Royal Court Young People's Theatre and her theatre work includes *Torn* (Arcola Theatre 2008) and *Shake What Ya Mama Gave Ya* (Riverside Studios). Films include the acclaimed *Rabbit Fever* and *Ruff 992 M*. Antonia was nominated for an EMMA award and won the Screen Nation Award for Best Emerging Talent and the GAB Best Newcomer award.

Marcy Oni

Marcy trained at the Academy of Live and Recorded Arts, London, where she enjoyed such roles as Hermia in *A Midsummer Night's Dream* and Rosie in *Humble*

Boy. She has toured extensively, playing a wide range of characters. One of her most memorable parts was in Theatre Centre's production of *God is a DJ* by Oladipo Agboluaje, for which she received the Dorothy L. Sayers Actor's Award. She performed in *Tiata Delights 08* (Tiata Fahodzi/Almeida and on tour with Eastern Angles). She has especially enjoyed shooting adverts for Barclays Bank as well as an interactive quiz for ITV.

Nick Oshikanlu

Nick has a long history with Tiata Fahodzi, recently directing Ade Solanke's play *Pandora's Box* at Tiata Delights 08 (Almeida Theatre) and assisting Femi Elufowoju, jr on *Joe Guy* by Roy Williams (2007). As an actor for Tiata Fahodzi he participated in *Tiata Delights 06* and *07*, *The Gods are Not to Blame* and created the character of Afolabi in *The Estate* (2006). Nick trained at Guildhall and works prolifically in theatre where his credits include *Bulletproof Soul* (Birmingham Rep), *The Fixer* (Almeida Theatre), *My Home* (London Bubble), *Crocodile Seeking Refuge* (Lyric Hammersmith) and roles for Riverside Studios, Arcola Theatre, Globe Players, Mirage Theatre Company, Half Moon Theatre Company, Charles Cryer Theatre and aCCentuate Theatre Company. TV appearances have been in *Holby City*, *Silent Witness* and *Little Miss Jocelyn* (BBC) and in radio: *A Long Journey* and *Playing Away* (BBC), *Preserved of God* (Big Heart Media).

Javone Prince

Javone trained at LAMDA and has been a member of the Royal Shakespeare Company. He recently appeared in Sean Holmes' production of *Loot* (Tricycle Theatre). Other theatres where he has worked include Birmingham Rep, the National, Royal Court, Almeida and Young Vic (*In the Red and Brown Water* as Ogun). He is well known as a regular on *Little Miss Jocelyn* (BBC/Brown Eyed Boy) and from roles in *Horrible Histories* (BBC/CBBC), *Murder Prevention*, *Tittybangbang* and *The Bill* (Talkback Thames). Javone played Jack in Lars Von Trier's film *Manderlay* and GI Patterson in *The Tiger and The Snow*

(Roberto Benigni). Radio includes *Lacy's War* and *Small Island*. Javone is returning to Soho Theatre and to Oladipo Agboluaje's writing having played various characters in *The Christ of Coldharbour Lane* (2007).

Chucky Venn

Born to Nigerian parents and raised in West London, Chucky grew up in a large household as the eldest of five siblings. The support of his family and three years of studying performing arts have given him an incredible drive and ambition which has been the credit for all the roles he has landed so far. Chucky's big break came as Curtis Alexander in Sky One's football soap *Dream Team*, prior to transferring to ITV's *Footballers' Wives*, *Sharpe's Peril* and *The Bill* and BBC1's *Holby City*. Films include *The Bourne Ultimatum*, *Batman: The Dark Knight*, and *Thick as Thieves* (with Morgan Freeman) and, in theatre, the recent hit *The Brothers*. He has been the recipient of a Screen Nation Award nomination. With several other movie projects due out this year, Chucky's career grows from strength to strength.

Creative Team

Oladipo Agboluaje Writer

Oladipo's adaptation of Kester Aspden's *The Hounding of David Oluwale* for Eclipse Theatre (national tour) received wonderful reviews. His plays include *Early Morning* (Futuretense/Oval House) and a version of Bertolt Brecht's *Mother Courage and her Children* (Eclipse Theatre). Recent work includes *Knock Against My Heart* and *God is a DJ* (Theatre Centre); *British-ish* (New Wolsey Youth Theatre); *For One Night Only* (Pursued By A Bear) and *Captain Britain* (Talawa/New Wolsey Theatre). *Iya-Ile* is his third production at Soho Theatre, following the critically acclaimed *The Christ of Coldharbour Lane* and *The Estate* (Tiata Fahodzi). Oladipo is adapting *The Estate* as a feature film for Heyman Hoskins and the UK Film Council and is currently writing a feature adapted from his short film *Area Boys* with director Mel Mwanguma for Focus Features.

Femi Elufowoju, jr
Director / Choreographer

British born to Nigerian parents, Femi trained at Bretton Hall, Leeds University and worked for six years as an actor, performing at the National, Royal Court and making radio plays for the BBC. In 1996 he trained as a Regional Theatre Young Director at Theatre Royal Stratford East before forming Tiata Fahodzi in 1997. His credits as a Director for Tiata Fahodzi include *Joe Guy*, *The Estate*, *The Gods are Not to Blame*, and national tours of *Abyssinia*, *Makinde* and *Bonded*. Femi's freelance association with flagship theatres nationally has yielded several successful productions including John Donnelly's *Bone* for the Royal Court, Alistair Elliot's translation of Euripides' *Medea* and Marcia Layne's *Off Camera* for West Yorkshire Playhouse, Richard Bean's *The Big Men* in the Olivier (part of the G8 season of plays at the National Theatre), Patrick Marber's *Dealer's Choice* for Salisbury Playhouse, and the devised *Tickets & Ties* and *It's Good to Talk* for Theatre Royal Stratford East. In 2008 Femi was Associate Director for *Cinderella* at the New Wolsey Theatre, Ipswich and recently played Peter Munyegera alongside Eamonn Walker, Indira Varma and Jude Akuwudike in the BBC 2 thriller *Moses Jones*.

ULTZ Designer

For about 40 years ULTZ has been directing and/or designing plays and operas in Britain and all over the world. He designed 15 world premieres at the Royal Court in the last decade, and it was there that he first worked with Femi Elufowoju, jr on *Bone*. He went on to design *The Gods are Not to Blame* and *The Estate* for Femi at Tiata Fahodzi. As an Associate Artist at Theatre Royal Stratford East ULTZ develops and directs new pieces of Urban Music Theatre: Jean Genet's *Play The Blacks Remixed*, Nirag Chag's *Baiju Bawra*, *Da Boyz* (a hip hop version of *The Boys from Syracuse*), and *Pied Piper – a hip hop dance revolution* which won a 2007 Olivier Award. He was part of the Creative Team for the stage version of *The Harder They Come* (Theatre Royal Stratford East / Barbican / Toronto / Miami).

Mojisola Bamtefa
Costume Designer

Storyteller, actor, costume designer and historian, Moji has realised costumes for Tiata Fahodzi's productions of *The Estate* and *The Gods are Not to Blame* and Badejo Arts' *Elemental Passions*. In 2007 she worked alongside Felix Cross for NITRO on a seminal outdoor installation in Trafalgar Square. Moji was theatre business manager for the Centre for Cultural Studies, University of Lagos, where she worked extensively as a costume designer and actor for the National Troupe of Nigeria and the Lagos State Council for Arts and Culture. Her many credits include *Saworoide (The Brassbells)* by Mainframe Films, *A Place Called Home*, *The White Handkerchief* and *Twins of the Rainforest* for South Africa M-Net. Moji runs IJAPA (ijapaokoyanrinbo@hotmail.com) a voluntary creative art organisation which encourages and aids young and disadvantaged people in discovering their innate talents and abilities.

Trevor Wallace Lighting Designer

Trevor's previous lighting designs for Tiata Fahodzi were for *The Estate* and *The Gods are Not to Blame*. Other work includes: *The Family Plays*, *Notes on Falling Leaves*, *Bone*, *Fresh Kills* and *A Day in Dull Armour* (Royal Court); *Hangover Square* (Finborough Theatre); *The Wild Party* (Electric Theatre, Guildford); *The Beau Defeated* (Bellairs Playhouse, Guildford); *West Side Story* (Courtyard Theatre, Stratford upon Avon); *Marat/Sade* and *Dark of the Moon* (Jermyn Street Theatre); *Jeff Wayne's The War of the Worlds*, *Comedy of Errors*, *Grimm Tales*, *Richard III*, *Cyrano de Bergerac*, *Les Enfants du Paradis*, *The Three Musketeers* and *A Midsummer Night's Dream* (Minack Theatre, Cornwall).

Simon McCorry (Creative Cabin)
Soundscape Designer

Music and sound design for theatre includes: *Why I Don't Hate White People* (Lemn Sissay, 2009), *Wild Turkey* (Naach 2008), *All African Stars* (Tiata Fahodzi 10th Anniversary at Theatre Royal Stratford East 2008), *Vincent River* (Old Vic Productions 2007), *Joe Guy* (Tiata Fahodzi 2007), *Bacchic* (Actors of Dionysus 2007/08), *The Hot Zone* (Conspirators' Kitchen 2005), *Mortal Ladies Possessed* (Linda Marlowe 2005), *All Fall Away* (Pursued By A Bear

2003). Film work consists of *Recurring* (Pheidias Films), *London's Languages* (Digital Fluid/Old Vic New Voices), *One Day* (Stockpot Productions; short listed for Kodak Best Short Film 2007), *U.bi.qui.none* (Studio Mejo) and *The Pick Up* (Handstand Films).

Tom Lucy Fight Director

Tom has twenty years' experience in film and television from performing in major movies such as *Gladiator*, *Batman* and *James Bond* adventures to stunt co-ordinator and 2nd Unit Director on many mainstream television series including *Moses Jones*, *Dr Who*, *Torchwood* and *Being Human*.

Kolawole Oluwole

Assistant to the Director

Kola Oluwole currently runs Time things Change! company with award winning playwright Bola Agbaje, facilitating workshops for young people. He has recently directed two plays written by young performers for the company's 'Press Play' project: *The Valentine Dilemma* and *The Cycle* (Albany Theatre). He directed *Say What* by Nadine White for the Windsor Fellowship Graduation Ceremony (Kensington and Chelsea Town Hall, September 2008). Kola's work in film includes directing the short *Like Father Like Son* and the feature *187 Days*, both for cinefilms production in conjunction with LDA (2008).

Milja Amita Kilumanga

Assistant to the Designer

After graduating in 2003 from Central Saint Martin's, Amita has worked on a number of productions for Theatre Royal Stratford East: *Hansel and Gretel*, *The Family Man*, *The Harder They Come*, *Jean Genet's Play The Blacks Re-mixed*. Other productions include *The Tempest* (Bounce Theatre), *The Hot Dots* (So&So Circus Company) and *Magic of Christmas* for Millennium Dance Company. Amita specialises in costume design and has also been involved in choreographing and performing salsa, as well as organising an annual float in the Thames Festival.

Louise Green

Company Stage Manager

This is Louise's fourth production with Tiata Fahodzi. She first joined the company in 2007 as ASM on *Joe Guy* and has since worked on *All African Stars 08* and *Tiata Delights 08*. Louise trained at Wimbledon

School of Art gaining a BA in Design for Performance, before being drawn into production and event management during her final year at university. She has since been working as a freelance stage manager. Work includes *The Stravinsky Project* (Michael Clark Company: National and World Tour), *Feast on the Bridge & Night Parade* (The Mayor's Thames Festival); *Collaborations* (London Contemporary Dance School).

Francesca Finney

Deputy Stage Manager

Francesca graduated from the Guildhall School of Music and Drama in 2003 since when she has worked on several productions as DSM including: *Arab – Israeli Cookbook* (Gate), *The Fever* (Young Vic), *The World's Biggest Diamond* (Royal Court), *Hot Boi* (Soho), *Watership Down* (Lyric) and *African Snow* (York Theatre Royal). For the last year and a half she has been CSM (on 'the book') for Pilot Theatre, working on the award-winning *Looking For JJ*, *Fungus The Bogey Man* and the 10 year anniversary revival of *Lord Of The Flies*. This is her third show for Tiata Fahodzi and she is delighted to be working on the prequel to *The Estate*.

Samantha Tooby

Assistant Stage Manager

Sam first took an interest in Stage Management when she worked as a Production Runner on the Opening Ceremony of the Wales Millennium Centre and its subsequent Royal Gala. Following this, she was DSM on *Romeo and Juliet* for the Everyman Theatre Company, Cardiff. She graduated from the Guildhall School of Music and Drama in 2008 with a BA Honours in Stage Management and Technical Theatre. She was also the winner of the 2008 Guildhall Gold Medal for Stage Management and Technical Theatre. Whilst training, Sam did an eight week placement on *Desperately Seeking Susan* (Novello Theatre) and worked as a Runner on *Chess in Concert* (Royal Albert Hall). Since graduating, her work has included ASM on *Marguerite* (Theatre Royal Haymarket), *The Stone* and *Over There* (Royal Court). She has also worked as a Production Assistant with Mark Rubinstein Limited on several shows, including *La Clique* (Hippodrome) and *Eddie Izzard Stripped* (Lyric).

tiata fahodzi
africans in british theatre

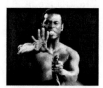

The Gods are Not to Blame
by Ola Rotimi

"spirited, humorous, involving stuff… tremendous"
**** Evening Standard on *The Estate (2006)*

The words 'Tiata Fahodzi' are an amalgamation of Yoruba (Nigeria) and Twi (Ghana) which translate as 'theatre of the emancipated.'

Founded in 1997 by the current Artistic Director, Femi Elufowoju, jr, the company is focused on exploring the cultural experiences of Africans in Britain through mainstream theatre. During the first ten years of its existence Tiata Fahodzi has produced classics of African theatre alongside new commissions from leading writers. It also provides opportunities for emerging writers and experimental work through Tiata Delights, the annual festival of African play readings, which has gained a strong track-record of discovering new plays which subsequently receive full productions. These include Oladipo Agboluaje's *The Estate* and Michael Bhim's *Pure Gold* for Soho Theatre and Levi David Addai's *Oxford Street* for the Royal Court. A Tiata Fahodzi event is always targeted towards a specific cultural group (Africans living in Britain) but is conceived to be enjoyed by an all-inclusive British audience. In recent years the company has had sell-out critically acclaimed productions, including the triumphant staging of Roy Williams' *Joe Guy* at Soho Theatre in 2007.

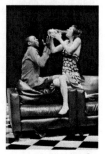

Joe Guy
by Roy Williams

"Energetic, exciting, and entertaining"
The Stage on *Joe Guy*

FUTURE PROGRAMME

2009 Summer *The Golden Hour* by Michael Bhim
African Music Concert
Co-presentation with Almeida Theatre

2010 Autumn *Medea* by Euripides
translated by Alistair Elliot

Commissions Bola Agbaje, Oladipo Agboluaje, Michael Bhim and Lucian Msamati.

The Estate
by Oladipo Agboluaje

Photos by
Stephen Cummiskey

Artistic Director
Femi Elufowoju, jr

Administrative Director
Thomas Kell

Press Representative
Nancy Poole
nancy@nancypoolepr.com

Consultant Producer
Roy Luxford

Office Assistance
Nilushika Alwis

Board
Archibald R. H. Graham (Chair)
Janice Acquah
Olu Alake
Jo Cottrell
Christopher Wilson
Jenny Worton

Honorary Advisors to the Board
Fiona Burtt
Adeboye Gbadebo
Fiona Sax Ledger

Patrons
Chiwetel Ejiofor
Jocelyn Jee Esien
Danny Glover

Tiata Fahodzi
AH112 Aberdeen Centre
22-24 Highbury Grove
London, N5 2EA
020 7226 3800
info@tiatafahodzi.com

Reg charity no. 1108416.

tiata fahodzi
africans in british theatre

Booked (1998)
Devised by Freddie Annobil-Dodoo, Angela Appiah, Femi Elufowoju, jr, Tunde Euba, Josephine Inoniyegha, Usifu Jalloh and Mary Njojo Nduta. Oval House and The Tabernacle, London.

Bonded (1999)
by Sesan Ogunledun
National Tour.

Makinde (2000)
by Femi Elufowoju, jr
National Tour.

Abyssinia (2001)
by Adewale Ajadi
National Tour.

Sammy (2002)
by Femi Elufowoju, jr
National Tour.

Steppin Out (2003)
by Angie Smith
Deighton Centre, Huddersfield.

Tiata Delights (2004)
A festival of new writing from Oladipo Agboluaje, Amma Duodu, Tunde Euba, Harold Kimmel, Reginald Ofodile and Debo Oluwatuminu.
Arcola Theatre, London.

It Takes a Whole Village (2004)
by Audrey Henry Quarcoo and Mycil Muhammed
Lawrence Batley Theatre, Huddersfield.

Appointment at Diamoniques (2004)
by Mel Mills
Lawrence Batley Theatre.

When Lighting Speaks… Home (2005)
by Debo Oluwatuminu
Open House Season, Soho Theatre, London.

The Gods are Not to Blame (2005)
by Ola Rotimi
Arcola Theatre.

Tiata Delights (2006)
A festival of new writing from Kofi Agyemang, Michael Bhim, San Cassimally, Segun Lee-French and Valerie Mason-John.
Soho Theatre.

The Estate (2006)
by Oladipo Agboluaje
Co-produced with New Wolsey Theatre, Ipswich and in association with Soho Theatre; performed at those theatres and at South Hill Park, Bracknell and Contact Theatre, Manchester.

Creation 2 Production (2006)
by Steven Downs and Steve Rock. An education initiative in association with South Hill Park.

Tiata Delights (2007)
A festival of new writing from Levi David Addai, Lizzy Dijeh, Beminabu Kebede, Suzan-Lori Parks, Lucian G W Msamati, Patrice Naiambana, Nayesh Radia
Soho Theatre, London.

Joe Guy (2007)
by Roy Williams
Produced in association with and performed at New Wolsey Theatre and Soho Theatre.

All African Stars Gala (2008)
A celebration of Tiata Fahodzi's Tenth Anniversary and of the excellence of British Africans in the arts.
Presented at and with the assistance of Theatre Royal Stratford East.

Tiata Delights (2008)
A festival of new writing and music with plays by Bola Agbaje, Francis Aidoo, Yvonne Dodoo, Rex Obano, Nii Ayikwei Parkes and Ade Solanke and a **concert** featuring Sola Akingbola, Tunde Jegede, James Lascelles, Leon Maddy and GK Real.
Co-presentation with Almeida Theatre.

Walking Waterfall by Nii Ayikwei Parkes (Tiata Delights 08)
Photo: Ade Omoloja

Eastern Delights (2008)
Two plays from Tiata Delights 08, *In Time* by Bola Agbaje and *Walking Waterfall* by Nii Ayikwei Parkes on tour in East Anglia in a ground-breaking initiative.
Co-produced with Eastern Angles theatre company.

Iya-Ile (2009)
by Oladipo Agboluaje
Co-production with Soho Theatre.

In 2007 the company launched a **Founding Friends** scheme to enable its supporters to play a greater role in safeguarding the heritage and future of this unique company. Tiata Fahodzi would like to thank its Founding Friends:

Adenike Balogun
Tim Fosberry
Lola Sarah Odofin
Helga Pile

Jo Cottrell
Linden Ife
Ayo Oyebade
Jenny Worton

Susan Worton
Lizzie Hogben
Taiwo Ajai-Lycett

New members are warmly welcomed and information is available from
Thomas Kell: 020 7226 3800 / thomas@tiatafahodzi.com.

PERFORMANCE PROVOCATIVE AND
COMPELLING THEATRE, COMEDY AND CABARET
TALKS VIBRANT DEBATES ON
CULTURE, THE ARTS AND THE WAY WE LIVE
SOHO CONNECT A THRIVING EDUCATION,
COMMUNITY AND OUTREACH PROGRAMME
WRITERS' CENTRE DISCOVERING AND
NURTURING NEW WRITERS AND ARTISTS
SOHO THEATRE BAR SERVING TASTY,
AFFORDABLE FOOD AND DRINK FROM
12PM TILL LATE.

Artistic Director Lisa Goldman
Executive Director Mark Godfrey

'The capital's centre for daring international drama.'
EVENING STANDARD

'A jewel in the West End.'
BBC LONDON

THE TERRACE BAR
Drinks can be taken into the auditorium and are available from
the Terrace Bar on the second floor.

SOHO THEATRE ONLINE
Giving you the latest information and previews of upcoming shows,
Soho Theatre can be found on facebook, myspace, twitter and youtube
as well as at sohotheatre.com. For regular programme updates and offers visit
sohotheatre.com/mailing

HIRING THE THEATRE
Soho Theatre has a range of rooms and spaces for hire. Please contact the
theatre on 020 7287 5060 or go to sohotheatre.com/hires for further details.

THE SOHO THEATRE DEVELOPMENT CAMPAIGN

Soho Theatre receives core funding from Arts Council England, London and Westminster City Council. In order to provide as diverse a programme as possible and expand our audience development and outreach work, we rely upon additional support from trusts, foundations, individuals and businesses.

To find out more about how you can make a vital contribution please contact the development department on 020 7478 0143, email development@sohotheatre.com or visit sohotheatre.com.

Soho Theatre is proud to acknowledge the following supporters:

Principal Sponsors and Education Patrons
Anonymous
Bloomberg
The City Bridge Trust
The Ernest Cook Trust
Esmee Fairbairn Foundation
The Harold Hyam Wingate Foundation
Latham Watkins
Roscolab Ltd
The Rose Foundation
St Giles-in-the-Fields Parochial Charities
TEQUILA\London
thelondonpaper

Trusts and Foundations
Anonymous
Chairman's Charitable Trust
G&J Charitable Trust
Hyde Park Place Estate Charity
The Mackintosh Foundation
The Royal Victoria Hall Foundation
The Teale Charitable Trust
Westminster Arts

Soho Theatre Ambassadors
David Day
Jack and Linda Keenan

Thank you also to our many Soho Friends who we are unable to list here.

Registered Charity No: 267234

Chief Olanrewaju Adeyemi's Nigeria

Nigeria's post-independence history has been scarred by political and economic instability. Soon after independence from Britain in 1960, violent changes of government by coup and the Biafran War of 1967-1970 showed the potential for Nigeria to fissure along regional and ethnic lines. The military took control in 1966 and would openly dominate politics for the next thirty years, creating an environment where Chief Adeyemi can only build his business empire through obeisance to powerful, capricious soldier-politicians. Between 1979 and 1989, when *Iya-Ile* is set, there were several major changes of administration, beginning with the peaceful handover from Obasanjo to Alhaji Shehu Shagari whose National Party of Nigeria (NPN) had won a contentious presidential election. In 1983, Shagari expelled more than a million foreign workers, principally Ghanaians, a move which was justified as providing more jobs for Nigerians. Shagari won a bitterly fought and much contested election later in 1983, and the resultant political volatility culminated in the Shagari government being

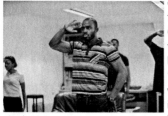
Chucky Venn

overthrown by Major-General Muhammad Buhari, thus ending the Second Republic. Buhari and Idiagbon (Chief of Staff) identified corruption and indiscipline as the main constraints on Nigeria's development, and launched a nationwide campaign against them called 'War Against Indiscipline' ('WAI'). The WAI campaign was aimed at tackling the more anti-social ills prevalent in the country such as 'indiscipline', corruption, and lack of environmental sanitation. Utilising force, including summary corporal punishment, as a lever, there was an immediate albeit grudging acceptance of new national standards of acceptable behaviour – queuing became all the rage and civil servants who were not at their desks by 8am were subject to public floggings! Although they had always cried out for a Government that would root out the rampant indiscipline in Nigeria, white-collar workers were irked when confronted with the reality of the extent to which Buhari/Idiagbon were taking the WAI campaign across the whole of Nigeria, regardless of status.

A further bloodless coup in 1985 brought General Ibrahim Babangida to power. Babangida took promising initial steps to reverse the human rights abuses of previous governments, freeing political prisoners and emancipating the press, and imposed efforts to improve civic society – such as continuing the Buhari/Idiagbon monthly compulsory Environmental Sanitation (general cleaning up of the community) which is taking place as the play opens. He implemented the 'liberalising' economic

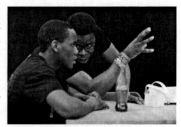
Femi Elufowoju, jr with Tobi Bakare

policies urged by the IMF and World Bank which brought some short-lived growth but, by the late 1980s, had to be reversed in the midst of rioting over decreasing public sector wages, increasing inflation, currency devaluation and minimal investment. Babangida's regime lasted until 1993 when, amidst widespread allegations of corruption and human rights violations and, despite repeated promises to the contrary, a calamitous refusal or inability to return the country to civilian rule, power was grabbed by General Sani Abacha, ushering in the political context for *The Estate*.

Femi Elufowoju, jr; Olu Alake and Thomas Kell

Visit www.tiatafahdozi.com for links to more information on Nigeria and to join in the debate.

In Rehearsal

Photography by Hugo Glendinning

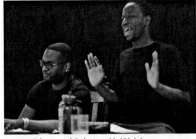

Javone Prince and Babatundé Aléshé

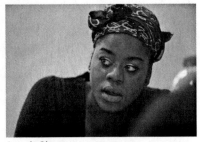

Antonia Okonma

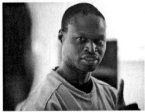

Oladipo Agboluaje

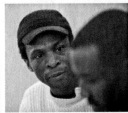

Jude Akuwudike

Marcy Oni

Tobi Bakare

Nick Oshikanlu

Estella Daniels and the company

ALMEIDA
THEATRE

SUMMER FESTIVAL 2009

8 July – 1 August 2009

Following last year's sell-out performances, Tiata Fahodzi return to the Almeida Theatre Summer Festival as part of three-weeks of cutting-edge theatre.

29–31 July, 7.30pm
THE GOLDEN HOUR
a new play by Michael Bhim
Tickets: £12.50

1 August, 8.00pm
CONCERT OF AFRICAN MUSIC
featuring The Ganda Boys
Tickets: £17.50

Other Festival artists include:
SLUNG LOW
THE TEAM
GULP

On sale now
Box Office **020 7359 4404**
www.almeida.co.uk

Coming soon from Tiata Fahodzi

Autumn 2010: National venues and London

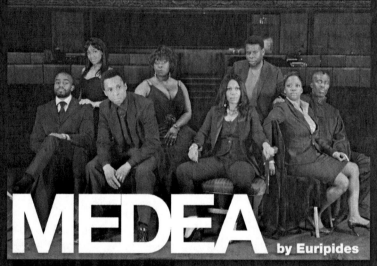

MEDEA
by Euripides

Translated by Alistair Elliot
Directed by Femi Elufowoju, jr

Jocelyn Jee Esien in the title role (centre)
with **Chucky Venn; Natalie Best; Jude Akuwudike; Ellen Thomas; Femi Elufowoju, jr; Ayo-Dele Ajana** and **Sola Akingbola.**

Tiata Fahodzi is forming a company of leading actors to create a new version of Euripides' classic story of love and revenge. In 2010 Femi Elufowoju, jr will be joined by long-term collaborator and designer ULTZ to revisit concepts from his 2003 critically acclaimed production at West Yorkshire Playhouse.

Alistair Elliot's vivid and powerful translation was originally made for Diana Rigg at the Almeida Theatre in 1992 and has not yet received a London revival. Femi Elufowoju, jr's production, re-adapted by Elliot, will be transposed to African soil and given a complete Tiata Fahodzi make-over, reaping the rich traditions of Yoruba storytelling and theatricality.

Medea is being produced with the support of Hackney Empire, London and New Wolsey Theatre, Ipswich. Further production news and touring dates will be posted on www.tiatafahodzi.com

Photograph of the Medea company at Hackney Empire by Robert Day.

IYA-ILE

First published in 2009 by Oberon Books Ltd
521 Caledonian Road, London N7 9RH
Tel: 020 7607 3637 / Fax: 020 7607 3629
e-mail: info@oberonbooks.com
www.oberonbooks.com

A catalogue record for this book is available from the British
Library.

ISBN: 978-1-84002-925-3

Cover photograph by Hugo Glendinning

Printed in Great Britain by CPI Antony Rowe, Chippenham.

Characters

CHIEF ADEYEMI,
late fifties aka Baba Yinka (Yinka's father)
TOYIN ADEYEMI, 40
YINKA ADEYEMI, mid-teens
SOJI ADEYEMI, mid-teens
LOMI PAKIMI, mid-20s
HELEN, 18
AFOLABI, late 30s
SOLDIER
MRS OKOMILE – Governor's Wife
ARCHBISHOP BILLY ROBERTSON
K K FOLARIN
ONIJUJU
PARTY GUESTS
DOMESTIC ASSISTANTS

The play is set in 1989, Lagos.

Act One

Saturday, before 9am. The sitting room of the Adeyemi Mansion. In a corner there is a box of party stuff: paper plates, plastic cutlery, decorations etc. HELEN, the house-girl, is in a corner kneeling down with her arms raised, in obvious pain. PAKIMI, terrified, dashes in with SOLDIER, horsewhip in hand, chasing after him. HELEN runs into the kitchen. CHIEF ADEYEMI comes downstairs.

CHIEF: Who is that?

PAKIMI: Chief, oh!

CHIEF: Officer!

SOLDIER ignores CHIEF and continues pursuing PAKIMI.

Officer, I'm talking to you!

SOLDIER catches PAKIMI and is about to whip him.

PAKIMI: Chief! I don die, oh!

CHIEF: Touch him and I will report you to your Commanding Officer! How dare you barge into my house?

SOLDIER stops, hatred in his eyes.

Get out!

SOLDIER exits. HELEN peeps through the kitchen door. She returns to her punishment.

I asked you get the car ready. What were you doing on the street?

PAKIMI: Ess sah, he's the one/

CHIEF: Shut up! Oloshi.[1] Helen! (*Waves to HELEN to get up.*)

1 Idiot.

21

HELEN: Ess sah, Madam/

CHIEF: Get up!

HELEN gets up.

Help Afolabi to clean the front yard. (*Exits upstairs.*)

HELEN: (*Curtsies.*) Lomi! You wan' die? You no fit wait make nine o'clock reach?

PAKIMI: It's because of you.

HELEN: No be me tell you to comot before environmental[2] finish. You lucky say Chief dey house. Dat soldier for pieces you.

PAKIMI: I have watched *Shaolin Temple.* I would have given that beast of no nation. (*Makes kung fu poses and Bruce Lee exclamations.*)

HELEN rubs her shoulders, unimpressed by PAKIMI's antics.

Hey, you're not grateful that I do like Amitabh Bachchan and risk my life for you, my lover. (*Sings a Bollywood love song, dances over to her and massages her shoulders.*)

HELEN: If you no disappoint me you for no need to massage me.

PAKIMI: N'tori Olorun,[3] Helen.

HELEN: I beg no talk n'gbati-n'gbati for me! You say we no go spend New Year for dis house. New Year pass, 'Oh, we go comot before Madam birthday.' Her birthday don reach, we still dey here.

PAKIMI: Once I collect my money from Benjamin we are on our way.

2 Environmental Sanitation: general cleaning that takes place once a month.
3 For the love of God.

HELEN: Before or after Madam take koboko[4] structurally adjust my back?

PAKIMI: Shebi you were there when Alhaji Mukaila increased the deposit?

HELEN: When dem increase workers salary you suppose to know say na so 'im go do.

PAKIMI: I'm not Archbishop Billy Robertson. If I could predict the future I too would be riding in Benz.

HELEN: All dis your talk, 'e dey enter dis ear comot for my nyash. All I know be say if Madam birthday meet us for here, all talk of marriage will be suspended until further notice by military decree with immediate effect and automatic alacrity. You hear?

PAKIMI: Pack your load. After I leave Benjamin, straight to Alhaji Mukaila. We are moving into that flat today-today. I promise. I will not disappoint you again.

HELEN: Swear.

PAKIMI: I swear on my father's grave.

HELEN: Ah, your papa don die?

PAKIMI: On my mother's grave.

HELEN: Lomi…

PAKIMI: On my grand… On my great-great-great… Allah.

HELEN: You, eh.

They embrace. HELEN pulls PAKIMI down on the sofa.

PAKIMI: Helen!

HELEN: You too dey fear. You suppose to say one day na so we too go live. I wan' be woman of my own house like dis. You hear me?

4 Horse whip.

PAKIMI: (*Anxious, eyes on the stairs.*) I hear you.

HELEN: I wan' my own duplex with swimming pool and garden.

PAKIMI: Ehen, ehen. Swimming pool and garden.

HELEN: I wan' car and driver.

PAKIMI: Car and driver. Batteries included.

HELEN: As our Mama and Papa dey pray, our children go better pass us. My parents struggle no go be in vain. I no go pass from poor to poverty.

PAKIMI: Poor to poverty. I will get it for you.

HELEN: Lomi!

PAKIMI: Sorry! In fact, the year 2000 will not meet us before I eradicate poverty from our lives…

The sound of a police escort followed by footsteps descending the stairs. PAKIMI dashes out through the front door. HELEN runs into the kitchen.

TOYIN and CHIEF ADEYEMI come downstairs.

TOYIN: A soldier entering my house? You must have him sacked.

CHIEF: Tell Mrs Okomile. (*Sniggers, adds Yoruba stress on the name.*) 'Oko mii le'.[5]

TOYIN: Lanre! Don't be lousy. (*Looks at the time worriedly. Follows him to the door.*)

CHIEF: Ehen?

TOYIN: I'm coming with you.

CHIEF: What about your guest?

TOYIN: My son is my priority/

———————

5 My penis is hard.

CHIEF: Toyin. If I have gone down in your eyes, the rest of society still holds me in high regard.

TOYIN: (*Looks around for HELEN.*) Ah, this girl has released herself.

CHIEF: I told her to help Afolabi clean up.

TOYIN: I punished her. She is my house-girl…

AFOLABI enters with MRS OKOMILE, the state Governor's wife. She is in awe of being in the presence of the Adeyemis.

AFOLABI: Mrs Okomile, Ma.

CHIEF: Thank you, Afolabi.

AFOLABI exits.

CHIEF: Mrs Okomile, welcome.

MRS OKOMILE: Good morning Chief.

CHIEF: How are you?

MRS OKOMILE: Fine Chief.

CHIEF: How is the Colonel?

MRS OKOMILE: He is fine sir. He sends his greetings.

CHIEF: Tell your husband he's the best governor this state has ever had. Tell him I said that.

MRS OKOMILE: I will tell him, sir.

CHIEF: When I saw him standing to attention on Independence Day parade, I said, this is the hard man Lagos needs. He is no soft banana. This cocksure man will penetrate hardened criminals like Shina Rambo and have them screaming for mercy.

MRS OKOMILE: He is working overtime to crush the armed robbers, sir.

CHIEF: Very good. Even an area like ours is no longer safe. Our neighbours the Smiths have hired Kolly Bolly.[6]

MRS OKOMILE: When my husband finishes with those animals, you will not need to hire private security.

CHIEF: Hm! At the rate he is going we won't want the civilians back.

MRS OKOMILE: Ah, Chief, oh! There is no going back on the transition to civil rule. The military knows its place.

CHIEF: Their place is to clean up once we bloody civilians make a mess, eh.

TOYIN: Ahem.

MRS OKOMILE: Ah, good morning Ma. Many happy returns. (*Gives TOYIN a birthday card.*)

TOYIN: Thank you. Please have a seat.

MRS OKOMILE: Thank you, Ma.

CHIEF: I am surprised though. When the General changed his title from Head of State to President I thought: this man is not going anywhere.

TOYIN: Oya, Baba Yinka.

MRS OKOMILE: You are on your way out, sir?

CHIEF: I'm waiting for nine o 'clock. Unlike you we do not have special dispensation to break the curfew.

MRS OKOMILE: It's my mission, sir. It is of the utmost importance.

CHIEF: It has to be of utmost importance for you to break the curfew.

TOYIN: That is what she said.

6 Private uniformed security firm.

CHIEF: I'm emphasizing it. Like a faithful, loyal and honest citizen I will wait for nine o 'clock.

TOYIN: It's time.

CHIEF: It isn't. You want Mrs Okomile to tell her husband to revive War Against Indiscipline? Come to think of it, WAI sounds like a soldier whipping a civilian: 'Wai! Wai! Wai!'

TOYIN picks up her handbag and stands up.

CHIEF: Sit down. (*Heads for the door.*)

CHIEF: See you later, Mrs Oko mii…

TOYIN: Lanre!

CHIEF: (*Pretend coughs.*) Mrs Okomile. (*Exits.*)

TOYIN: Helen!

HELEN: (*Off.*) Ma!

TOYIN: What can I offer you?

MRS OKOMILE: Tea, ma. Thank you, Ma. I hope no problem? (*Points to the departing CHIEF ADEYEMI.*)

TOYIN: Eh, it's a personal matter. What can I do for you?

HELEN enters.

TOYIN: Where were you?

HELEN: I dey for backyard, Ma.

TOYIN: Did you wash your hands?

HELEN: Yes Ma.

TOYIN: Make tea for Mrs Okomile.

HELEN: Yes Ma. (*To MRS OKOMILE.*) Lipton or Bournvita, Ma?

TOYIN: What do we call tea in this house? Bring the wrong one, you will see yourself.

HELEN exits to kitchen.

MRS OKOMILE: First let me assure you, Ma, that the Association of Governors' Wives will be here in full force to celebrate your fifty years on this earth.

CHIEF enters.

CHIEF: I forgot my briefcase. (*Goes upstairs.*)

TOYIN: Couldn't you tell Pakimi to get it for you?

CHIEF: (*Looks about on the landing.*) I can't remember where I left it.

TOYIN: You didn't leave it there.

CHIEF: It must be in my room. (*Exits upstairs.*)

MRS OKOMILE: I don't know if you remember me, Ma. I was your student. What a great principal you were. I wept the day you retired. Those sermons you gave during morning assembly inspired me to make something of myself. You taught us that it wasn't a man's world. We girls could make something of our lives.

TOYIN: I was just doing my job.

MRS OKOMILE: If not for you I would not be where I am today. I am helping our country wean itself off its insatiable appetite for foreign goods which is a drain on our foreign exchange reserves thus indebting us to foreign banks. Meanwhile our locally made products are perceived with the same contempt reserved for goods made in China. I assure you, the government is making all effort to ensure that by the year 2000 you will see the label 'Made in Nigeria' as a mark of quality.

TOYIN: We shall be here in 2000.

MRS OKOMILE: Amen, Ma.

CHIEF comes downstairs.

CHIEF: Ogbele, oh. Is it in your room?

TOYIN: How can it be in my room? Did you check inside your study?

HELEN enters with the tea.

CHIEF: Yes, now. (*To HELEN.*) Is my briefcase in the kitchen?

HELEN: No sah.

CHIEF: Maybe I left it in the toilet. (*Enters the toilet. Shuts the door.*)

MRS OKOMILE: Yes Ma/

TOYIN cuts her off with a wave. They wait. HELEN stops, thinking TOYIN's gesture is for her. TOYIN waves impatiently to HELEN to put down the tea. She inspects it.

TOYIN: Olorun yo e.[7]

MRS OKOMILE: Yes Ma/

TOYIN gestures to her not to talk. At last, CHIEF comes out.

CHIEF: It's not there.

TOYIN: Were you searching inside the cistern?

CHIEF: I had to relieve myself. Helen did not pound that yam very well.

TOYIN: You didn't complain last night.

CHIEF: It's pounded yam now. It has delayed effect, not like beans. (*To HELEN.*) Check the kitchen, maybe I left it there.

TOYIN: You didn't flush.

CHIEF: Ah, look at me. (*Goes back and flushes the toilet.*)

MRS OKOMILE: The First Lady is/

CHIEF: (*Inside the toilet.*) Na wa for this shit, oh.

TOYIN: I do apologize.

7 God saved you.

MRS OKOMILE: It's OK, Ma. When you're married to a soldier you hear all kinds of vulgarities.

TOYIN: Chief is not a vulgar man.

MRS OKOMILE: Of course not Ma! I meant that when you live in the barracks you/

CHIEF: (*Flushes again.*) You would have thought that André the Giant shit this shit. Or is it shat this shit?

TOYIN: Get out of there!

CHIEF: (*Comes out.*) Take it easy now.

HELEN: I no see am for kitchen, sah.

CHIEF: I will look for it later. Give the toilet one more flush. See you. (*Dithers.*)

HELEN goes into the toilet. She comes out.

HELEN: Essa, nothing/

CHIEF: Flush it!

HELEN goes back inside the toilet and flushes, leaving the door open.

CHIEF waits. TOYIN glares at him. He exits sheepishly.

TOYIN: Please…

HELEN shuts the toilet door and comes downstairs.

MRS OKOMILE: It's all right, Ma. As I was saying/

TOYIN: (*To HELEN.*) You are in your cave, that is why you did not shut the door before you flushed. Because that toilet looks like a shalanga[8] to you, abi? Get out!

HELEN curtsies and exits quickly.

TOYIN: Ojare…

8 Pit latrine.

MRS OKOMILE: It's all right, Ma. If not that the First Lady is on official trip to Dubai she would have met with you personally… Her initiative, the Better Life for Rural Women continues to grow, providing women in our rural areas the opportunity to fully maximise their profits in their given trades which allows them to sustain a better standard of living thus leading to/

TOYIN: Mrs Okomile. I know all about Better Life. What has it got to do with me? I'm not a rural woman.

MRS OKOMILE: Yes Ma. I mean, no Ma. Due to her numerous commitments the First Lady has decided to step down. To this effect, we are seeking a new chairwoman, one whose standing among women is beyond comparison, one who can build upon the solid foundation laid by our First Lady. Without too much thinking you were the only person we thought worthy of the job.

TOYIN: I see. Thank you for considering me without too much thinking.

MRS OKOMILE: We knew that, as a mother of the nation, you would answer the call of duty to ensure that our country continues to grow spiritually and economically/

TOYIN: I am the secretary of the National Council for Women Society.

MRS OKOMILE: And we appreciate the efforts of the Society in representing women of high status. By heading our association you will bridge the gap between the National Council members and those women who are less fortunate. You will answer directly to the First Lady which is an honour in itself.

TOYIN: I cannot rush into a decision on a matter as important as this.

MRS OKOMILE: Ah. Em, how soon will I get a reply from you, Ma?

TOYIN: I can't say.

MRS OKOMILE: It's only that I would like to know before the
First Lady's birthday next month.

TOYIN: I see. I will get back to you. (*Stands up.*)

MRS OKOMILE: (*Stands up.*) Ah, OK, Ma. Thank you for your
time.

TOYIN: Ehen. Bye-bye.

MRS OKOMILE exits.

Ariifin buruku.[9] (*Yells.*) Helen!

HELEN enters and clears the table.

Get me water. (*Takes a box of tablets from her handbag.*)

*HELEN dashes back into the kitchen and returns with a glass of water.
TOYIN swallows two tablets. HELEN clears the table.*

SCENE TWO

*Later that morning. The sitting room. AFOLABI and HELEN exit and
enter, bringing party stuff into the sitting room. TOYIN looks anxiously
through the window and at her wrist watch. AFOLABI puts down a box.
HELEN urges him to approach TOYIN. He is reluctant. HELEN shoves
him forward and exits. AFOLABI approaches TOYIN. The phone rings.
TOYIN answers it. AFOLABI exits. HELEN enters with another box.*

TOYIN: Hello? Oh, 'Bidemi. Yes? Ah, you've spent last
month's allowance already? Quiet! Did your useless
husband impregnate me or you? Find your way to
the family planning clinic instead of dumping your
responsibilities on me. (*Hangs up.*) It's only when you need
money that you remember I'm your sister. (*Resumes her vigil
by the window.*)

AFOLABI and HELEN enter with boxes.

9 Bloody cheek.

AFOLABI: Ess, Ma. You say I should tell you when the cow people arrive.

TOYIN: Ehen, thank you, Afolabi.

AFOLABI: Chief say I should keep it secret, but if you see how I redecorate the garden for your birthday party, ah, is very beautiful, Ma... Em, ess' Ma. About my son, Ikililu. The doctor say his condition is not change at all and the medicine is too cost.

TOYIN: Did Chief say he would branch at the Ministry of Petroleum?

AFOLABI: No, Ma.

HELEN exits, shaking her head.

TOYIN sighs. She picks up her handbag. As she is about to leave with AFOLABI...

CHIEF: (*Off.*) I should have packed you off to join your brother in the hostel. (*As they enter CHIEF whacks the back of SOJI's head.*) Get inside! Idiot.

TOYIN: Baba Yinka! The soldiers did not kill him, you want to finish him off. (*Hugs SOJI. Checks him all over.*)

AFOLABI: Welcome, sah. Welcome Soji/

SOJI: I'm fine, Mum.

CHIEF: He is not fine. He is sick in the head!

TOYIN: Don't talk about my son like that.

CHIEF: I'm supposed to see General Abubakar this morning. Instead I've spent the whole day saving this miscreant's life.

TOYIN: Soji, when will you stop this Folarin business?

SOJI: K K Folarin speaks the truth! This military government is an illegal occupier. We must get them out.

CHIEF: Were you deaf when they announced their transition to civil rule?

SOJI: They are not going anywhere. They are using the transition programme as another opportunity to loot.

TOYIN: And that is what possessed you to stage a protest in front of Dodan Barracks?[10] Soji! You want to get yourself killed? (*Takes pills out of her handbag.*)

AFOLABI exits to kitchen.

SOJI: Someone has to stand up/

TOYIN: Shut up!

AFOLABI returns with a glass of water.

CHIEF: You see? You don't want your mother to see fifty. This foolishness ends today.

SOJI: We can't stop protesting until they release K K Folarin from detention. He's our only hope for the people's revolution. (*To AFOLABI.*) You get what I'm talking about, Afolabi?

AFOLABI: Er, er…

SOJI: You said you would stand shoulder to shoulder with me at the barricade/

AFOLABI: (*As if answering someone offstage.*) Yes! I'm coming oh! (*Runs out.*)

CHIEF: You see? No one with half a brain will join your stupid revolution.

SOJI: If you could have felt the rush I felt when I stood with my comrades before the soldiers' guns singing 'Zombie' you would understand.

TOYIN: Was it not one of your comrades who told the security agents where to find Folarin?

10 Official residence and headquarters of the President.

SOJI: That's government propaganda! K K Folarin says that emancipation can only come from/

CHIEF: Does K K Folarin pay your school fees?

SOJI: He is fighting for my future.

TOYIN: Soji…

CHIEF: So what have I spent my whole life working for if not to secure your future? Next time I will leave you to rot in detention with your 'comrades'. Or you don't know that it is my name that protected you from being tortured? Talk to your son. Talk to your son! Ungrateful bastard. Pakimi! (*Storms out through the front door.*)

TOYIN: Baba Yinka? Baba Yinka! (*Turns to SOJI.*) Why can't you be like your mates? At least wait until you get into university before you start playing Mr Student Union.

SOJI: I'm not playing.

TOYIN: Are you not prepared for your SSS[11] exams?

SOJI: I didn't protest because of my exams, Mum!

TOYIN: You're trying to impress your girlfriend.

SOJI: Jesus Christ, Mum!

TOYIN: Soji! What did I tell you about swearing?

SOJI: Sorry, Mum. But you can't tell me you don't see those kids searching through our dustbins every morning.

TOYIN: What is my business with them?

SOJI: We're one of the biggest oil exporters yet everywhere I look I see people suffering. Yesterday by my school a mob stoned a man because he stole an orange. Mum, an orange!

TOYIN: That is one less armed robber to worry about.

SOJI: He stole it because he was hungry.

11 Senior Secondary School.

TOYIN: There will always be rich and poor. You behave like an atheist, that is why you refuse to accept that fact of life.

SOJI: And what about my comrades locked up for demanding our human rights? Should I accept that as a fact of life?

TOYIN: If K K Folarin chooses to spend his life in jail that is his business. He should not drag you into it.

SOJI: He opened my eyes. The first time I heard him speak I knew I couldn't be the same person again. I found my mission.

TOYIN: Still so gullible. You cannot change the world.

SOJI: I can't accept the unacceptable.

TOYIN: You can demonstrate till the cows come home, they won't release him.

SOJI: Then I will keep on demonstrating.

TOYIN: I still don't understand what has brought this change in you, and why you show more love for this man whom you've never met than you show for your father.

SOJI: I respect him. He uses his position to help others.

TOYIN: You know how many people your Father has sponsored their education? Folarin is not a god. We knew him when we were students in London. Even back then he was a self-righteous nuisance. Making us feel guilty for not joining the Pan-African movement. Your father's nickname for him was nose-picker.

SOJI: He can wipe his anus with his hand, I would shake it.

TOYIN: You know why your Father called you ungrateful? Because you behave as if the golden spoon in your mouth is plastic.

SOJI: What is wrong in making our country a better place for all of us?

TOYIN: Omode nse e.[12] What life have you lived that you think you can solve Nigeria's problem? The hungry are in their houses. You are on the streets risking your life for them.

SOJI: I'm a future leader. I have a responsibility.

TOYIN: Your responsibility is to yourself! Mrs Eborie's son, in his final year, what did he die for? So that the riffraff could loot! You want me to feel her pain? Give thanks to God that you are born into this family.

SOJI: Soyinka was right. Yours is the wasted generation.

TOYIN: My joy is that you are safe and sound. Don't you ever repeat that statement to me or to your father if you want to stay under this roof. Do you hear me?

SOJI: Yes, Mum.

TOYIN: Now, let's get you something to eat. Helen!

HELEN: (*Off.*) Ma!

TOYIN: What are you getting me for my birthday, eh?

SOJI: (*Sullen.*) It's a surprise.

HELEN: (*Enters. Her hands are dirty.*) Ma.

TOYIN: (*Sees her hands.*) Where have you been?

HELEN: The sink block, Ma.

TOYIN: And you brought those dirty hands into my kitchen? (*Rummages under the sofa.*)

SOJI: Mum/

HELEN: I be wan' wash am, Ma. Di water don go, Ma! Di water don go!

TOYIN brings out a horsewhip and thrashes HELEN.

12 Don't be childish.

SOJI: Mum!

TOYIN: Wash your hands, serve my son his breakfast and after you will clean the whole kitchen. Let me see one smudge, wa gba Olorun l'oga.[13] Animal.

HELEN exits.

TOYIN: That is the riffraff you're risking your life for. They will kill you first with their backwardness. (*Puts the horsewhip back under the sofa.*)

SOJI: Try treating her like a human being.

TOYIN: If you're not hungry tell her not to bother.

SOJI: It won't kill you to/

TOYIN: Your foolish revolution stays outside. You do not tell me how to run my house. Or you want to marry her? Tell me so that I can flush both of you down the toilet this instant. Then I will know that I have no son. (*Storms into the kitchen.*)

SOJI waits for a beat then follows after her.

SCENE THREE

The sitting room. Later that day. TOYIN is going through a box of photographs. The box of paracetamol is in front of her. She puts it into her handbag. HELEN stands behind her holding a photo album. HELEN hands TOYIN the album. When TOYIN is not looking, HELEN rubs her back. AFOLABI enters, with CHIEF's briefcase. CHIEF enters and slumps onto his chair. AFOLABI exits.

CHIEF: (*To HELEN.*) Get me a beer.

HELEN curtsies and exits to kitchen.

What's that?

13 You will accept God as your lord.

TOYIN: I need a photograph for the programme cover. I'm thinking the one I took last year in Paris.

CHIEF: Good.

TOYIN: Kunle called. He says hello… I said Kunle called/

CHIEF: I heard you.

HELEN enters with the beer and a glass. She opens the beer and pours it. She curtsies and returns to TOYIN.

TOYIN: How was work?

CHIEF: Same-same. What did Mrs Okomile want?

TOYIN: She's looking for a new Better Life chairwoman. Bloody cheek, she needed an answer before the First Lady's birthday. She wants to present me to her in wrapping paper. That Dubai trip is nothing more than a shopping jamboree.

CHIEF: That's a rumour.

TOYIN: Are you serious? As if that wasn't enough Mrs Okomile invited herself and her cohorts to my birthday.

CHIEF: You could have invited her.

TOYIN: Why would I want goodtime girls at my birthday?

CHIEF: Kunbi is an architect.

TOYIN: And so?

CHIEF: I've told you, don't cast aspersions on my sister. Ah-Ah! Just because she's married to a Brigadier.

TOYIN: And I told you my brother says hello. Did I mention Kunbi's name? Was it not Mrs Okomile I was referring to?

CHIEF: It doesn't matter what you think. Their husbands are in government.

TOYIN: And that gives them the license to misbehave? Dr Otolorin was made to kneel in engine oil. What was his crime?

CHIEF: Otolorin by name, Otolorin by nature. Challenging a man with a gun. I don't know how he's managed to stay alive under military rule.

TOYIN: You wouldn't find it funny if it had been you.

CHIEF: They know who I am.

TOYIN: Hoh! Did a recruit not trample through our living room with impunity this morning?

CHIEF: And I sent him packing.

TOYIN: What about the animals that beat up Basorun Abiona? Did they not know who he is? They won't catch armed robbers, it is to go and beat up innocent people in their homes.

CHIEF: It is talk like this that encourages Soji.

TOYIN: I suppose Yinka is my fault too.

CHIEF: You said it.

TOYIN: No one could have foreseen General Abubakar becoming the new petroleum minister.

CHIEF: Only you could not have foreseen it.

TOYIN: I don't know why you're so worried. He has to honour your contract.

CHIEF: What did you tell Mrs Okomile?

TOYIN: Why are you interested?

CHIEF: Why shouldn't I be interested in my wife's affairs?

TOYIN: I should record this moment for posterity.

CHIEF: Why can't you answer a simple question without bringing up all kinds of irrelevancies?

TOYIN: So I'm irrelevant. (*Snaps her fingers at a nearby table.*)

CHIEF: Did I say you were irrelevant?

HELEN picks up a coaster from the table and puts it under CHIEF's glass.

N'gbo, Helen, you heard me call Madam irrelevant?

TOYIN: You are bringing Helen into my matter?

CHIEF: Sorry Ma.

TOYIN: You are bringing Helen into my matter!

CHIEF: I said sorry, oh!

TOYIN: You continue to amaze me, after how many years of marriage. Maybe you sent Mrs Okomile to talk to me.

CHIEF: It was only when you told me that I knew she was coming.

TOYIN: And yet you were so interested in our conversation.

CHIEF: It was the pounded yam.

TOYIN: Don't lie to me!

CHIEF: Forget it. (*Gets up. Heads for the door.*)

TOYIN: Where are you going?

CHIEF: I have another business appointment.

TOYIN: Which other appointment?

HELEN quickly dips her hand into TOYIN's handbag and pockets the paracetamol.

TOYIN: I said I would think about it.

CHIEF: (*Stops.*) And?

TOYIN: I'm still thinking.

CHIEF: It will be another feather in the Adeyemi cap. It's your rightful place to be the mother of the nation. Show that

fool son of yours that you can serve your country without trying to overthrow everybody.

TOYIN: When are you back?

CHIEF: After I see General Abubakar I need to change money. Four naira to one pound. Can you imagine?

TOYIN: Let Helen get Pakimi for you.

CHIEF: I'll drive myself. You will need him to run errands.

TOYIN: Lanre…

CHIEF: What is it now?

TOYIN: …When you return.

CHIEF exits.

TOYIN looks forlornly after him.

You want me to tell you before you clear the table?

HELEN clears the table and exits to kitchen.

God knows your time is coming.

HELEN pulls faces behind TOYIN's back and exits.

SCENE FOUR

The boys' quarters, later that day. HELEN is packing her things out of the store into a bundle. She stops to take two tablets then resumes packing. AFOLABI is outside listening to a comedy show on the radio. There are coolers nearby.

AFOLABI: Chief Zebrudaya[14] ma ferin pa mi o![15] Are you not going to wash those coolers before Madam bulala[16] you?

HELEN: If she see me to beat.

14 Nigerian comedian.
15 Don't kill me with laughter.
16 Whips.

AFOLABI: Is how she treat Maria before you, and Comfort before Maria, and/

HELEN: I beg, I no ask you for book of Chronicles.

AFOLABI: Now that you know her ways, you have to monitor yourself. Everything in life is patience. Patience and understanding. (*Roars with laughter.*)

HELEN: Dat one no concern me anymore. I sure say di woman na witch.

AFOLABI: Na you get your mouth.

HELEN: If you hear as she dey abuse Chief. 'You dis "irresigancy", you dis "konkobility", you dis second-hand machine gun'… If she no be witch how woman go abuse her husband he no go slap her face?

AFOLABI roars with laughter.

Anyway, me I thank God. I no go do servant for sixteen years.

AFOLABI: I am not servant. I am gardener.

HELEN: But sixteen years! You don become Adeyemi. Once you tell Madam say your pikin no well, she suppose to put hand for pocket immediately.

AFOLABI: Is her money. She can give whoever she like.

HELEN: My star cannot shine in dis house. I no surprise say Maria tief Madam bracelet.

AFOLABI: And that is why they call police for her.

HELEN: If you wan' help person and di only way na to tief, you no go do am?

AFOLABI: Maria tief to help herself.

HELEN: (*Slowly brings out the paracetamol.*) Ehn, but if na to save person life, nko?

AFOLABI: You see all the mola[17] with one hand wey dey beg for road? That is what happen to person who tief.

HELEN throws the paracetamol at AFOLABI.

AFOLABI: Helen! If Madam catch you/

HELEN: (*Extends her hand.*) If you no want am…

AFOLABI: Thank you.

HELEN: How Ikililu body?

AFOLABI: His matter has pass panadol. I am praying people will spray us at Madam party so I can buy the rest medicine.

HELEN: Na you on your own be dat. (*Comes out with the bundle.*) Me and Pakimi, we dey check out like 'Andrew' today-today.

AFOLABI: Helen, are you serious?

HELEN: I go invite you make you come see our flat. Two bedroom in Aguda.

AFOLABI: You want to rely on his 419 to feed you?

HELEN: If you know any rich man wey wan' marry me, make you tell me.

AFOLABI: My friend Alhaji is looking for fourth wife.

HELEN: God forbid.

AFOLABI: I know Christian who have more than one wife.

HELEN: Me I no fit do mistress for any man. Dat is like harlot.

AFOLABI: If you work hard you can be rich for yourself.

HELEN: Then you for don become millionaire. If to say I be rogue, no be only panadol I for tief from Madam/

17 Mallam/s.

AFOLABI: But you are not rogue so why are you following Pakimi…

PAKIMI enters as the advert for Forum Bank comes on.

RADIO: Forty per cent interest upfront on any deposit guaranteed. (*Jingle.*) 'Forum Bank, the bank for future millionaires'.

HELEN: Hey! My husband. I don ready.

PAKIMI: Em. Afolabi, excuse us.

AFOLABI: You be soldier?

PAKIMI: Excuse us, now.

HELEN: Afolabi know. Oya. Help me put am for my head.

PAKIMI: I didn't see Benjamin.

HELEN: Wetin you mean?

PAKIMI: He did not turn up.

HELEN: Maybe he meet go-slow for road.

PAKIMI: I went to his house. The landlord said there is nobody by that name living there.

HELEN: Na wrong house you go.

PAKIMI: He has run away with the money, Helen.

AFOLABI: Hey! 419 e ti gba e loju pada.[18]

HELEN: But you say Benjamin is honest person.

AFOLABI: (*Laughs.*) Benjamin that is professional 419?

PAKIMI: Give me until after Madam party. I will have the deposit.

HELEN: No. No! I cannot stay here. I cannot stay here!

18 Your fraud has caught up with you.

AFOLABI: Make you wash di cooler, quick-quick. You are not going anywhere.

HELEN: (*In a daze. To AFOLABI.*) Di panadol.

AFOLABI: What of Ikililu?

HELEN and AFOLABI struggle over the tablets. PAKIMI intervenes. HELEN beats him.

SOJI enters.

SOJI: Hey! Hey.

They stop fighting.

You should be united in your suffering so that you can overthrow the oppressor.

AFOLABI: Ah, you nearly cause me wahala today with that talk. You too, causing trouble for yourself when your exams are so close.

SOJI: How can I think of my exams when there's a war on?

AFOLABI: War? Hepa!

HELEN: (*Makes to dash out with her bundle.*) Ah! War oh!

PAKIMI: Soji is talking catastrophically.

SOJI: You mean metaphorically.

AFOLABI snorts in derision.

Helen, are you leaving us?

HELEN: When you say war… Oh. (*Puts the bundle back inside her room.*) I bin clean di store. I no dey go anywhere. So which war you dey talk?

SOJI: The one between soldiers and civilians.

AFOLABI: But the soldiers are going. Tradition to civil rule.

PAKIMI: Hey! Afolabi ta bon![19] Transition not tradition. Thank God I wear my bulletproof.

AFOLABI: I can speak English better than you. 'Catastrophically'.

SOJI: Guys, guys. Only one division matters: that between rich and poor. That gap is being widened by the military's avariciousness.

HELEN: Soji, the President is not from Mauritius.

AFOLABI: Maybe his grandfather.

SOJI: I didn't say Mauritius. I said/

PAKIMI: What is your own with poor people's problem, sef?

SOJI: Rich, poor, we must all struggle together. According to K K Folarin/

PAKIMI: K K Folarin will drop his Aluta Continua once they flash government post in his front.

SOJI: Lailai![20] Anybody who accepts an appointment from this government is a traitor. Who said that?

PAKIMI: The man is using you. He knows the system. He protests against the government, they make him a minister.

AFOLABI: Don't mind Pakimi, Soji. Everybody is 419 like him.

SOJI: You think he's endured all the detentions and the beatings to become part of them?

PAKIMI: Omo,[21] this world is all about kudi, owo, ego.[22] Even for woman to look at you, you must land naira first. And if you disappoint her before she forgives you, you must discharge again. No romance without finance.

19 'Fired a bullet' – slang for making a grammatical error in English.
20 Never.
21 Kid.
22 *Kudi, owo, ego*: money.

SOJI: Not everything is about money.

PAKIMI: Because you have money.

SOJI brings out money from his pocket and gives it to AFOLABI.

AFOLABI: Ah! Brother Soji.

SOJI: For your son.

AFOLABI: I can't.

SOJI shoves the money into AFOLABI's willing hand.

AFOLABI: Thank you, Brother Soji. May Allah replenish your pocket.

PAKIMI: My own child is sick.

SOJI: You don't have a child.

PAKIMI: In future.

SOJI: In the future none of you will beg for crumbs from the master's table. There won't be a master.

PAKIMI: New table, same master.

SOJI: You are too cynical, man!

PAKIMI: Your mother is going to become chairwoman of Better Life.

SOJI: Mister Pakimi!

PAKIMI: I heard Chief talking to Mrs Okomile.

SOJI: Mum hates the military. There's no way on earth/

YINKA enters with a bag. He walks with a gangsta swagger, holds his crotch.

YINKA: Still talking about a revolution, eh?

SOJI: Hostel boy! When did you land?

YINKA: Just now.

AFOLABI: Yinka! Welcome.

YINKA: Mr Afolabi! How body?

AFOLABI: Body dey inside cloth.

PAKIMI: Ogbologbo![23] The hard man. (*Play-boxes with YINKA.*) Which one, now? She, you dey oppress all those fine babes for hostel?

YINKA: I'm Oppressor Numero Uno, accept. Are you Helen?

HELEN: Yes, sir.

YINKA: Mum wants the coolers. (*Eyes her.*)

HELEN: Yeh!

HELEN washes the coolers quickly. PAKIMI tries to help her. She pushes him away. AFOLABI laughs.

PAKIMI: I will spoil your garden.

AFOLABI: Eh, if you try it, eh… (*Goes after him.*)

SOJI: Remember! Save the fight for the revolution! (*To YINKA.*) Hostel Boy! (*Copies his swagger, tries to hit his crotch.*) Your old mates keep asking after you. You'll jam them at the party.

YINKA: Cool.

SOJI: (*Grabs YINKA's bag.*) What's this? 'Thunder in Heaven, parts five and six.' (*Unimpressed.*) It's homemade.

YINKA: Guys are saying this is going to be the latest craze.

SOJI: Yeah. This your bounce, eh. You've become ogbologbo true, true.

YINKA: You have to be or else guys will chance you. Everybody must know their level, you get what I'm saying? You should see what we get up to after lights out. Man,

23 Hard man.

I've been living a sheltered life. (*Keeps getting distracted by* HELEN.)

SOJI: Have you thought of a present for Mum?

YINKA: We'll get her something expensive.

SOJI: I'm short on card.

YINKA: What crap are you telling me?

SOJI: Easy, ah. I'll rustle up my half, don't worry.

YINKA: I'm starving. What's for dinner?

SOJI: There are people who go oh-oh-one[24] every day.

YINKA: Turn off that tap. K K Folarin's been released.

SOJI: Na lie.

YINKA: It was on the news a few minutes ago. I thought you knew/

SOJI: (*Jumps with delight.*) Yeah! People power, man! The revolution will be televised. Sign up now before the people rise up.

YINKA: Cool. Go celebrate on your own. (*Pretends to beat SOJI.*) Clear!

SOJI exits singing.

YINKA turns to HELEN.

YINKA: Hi there…

Gunshots. Shouts of 'ole', 'thief' and 'armed robber'. YINKA and HELEN run off.

24 One meal a day.

SCENE FIVE

That night. YINKA and TOYIN at table. Christy Essien Igbokwe's 'Omo mi seun rere' plays.

AFOLABI: The Smiths, they are all fine.

TOYIN: Thank God.

AFOLABI: Is their motor that they carry.

TOYIN: It's just a car.

AFOLABI: And their TV and stereo system.

TOYIN: They can be replaced.

AFOLABI: And all Madam's jewellery. And all the money/

TOYIN: So they robbed them of everything.

AFOLABI: Eh, yes Ma.

TOYIN: Thank God no one got hurt.

AFOLABI: They shoot the 'security' in the leg. And they burn one of the armed robbers.

TOYIN: Tell them I will come round with Chief this evening.

AFOLABI: Yes Ma. (*Exits.*)

YINKA: Soji! Where are you!

TOYIN: Yinka! What did I say about shouting in the house? If it was Soji I would understand. You still haven't explained what possessed you to take public transport.

SOJI comes downstairs, dressed in khaki shirt and shorts. He goes to the stereo and replaces the music with Fela Kuti's 'Sorrow, Tears and Blood' before sitting at the table. HELEN enters with food and puts it on the table. She stands to one side. YINKA glances at her.

YINKA: I wanted to surprise you.

TOYIN: Never again. You tell us you're coming and we send Pakimi to pick you. OK? Nowhere is safe. God knows who you were sitting next to on that filthy bus.

YINKA: It was Ikene dili Chukwu.[25]

TOYIN: So what? I hope you chartered a taxi from the motor park. I said I hope you chartered a taxi.

YINKA: Molue.[26]

SOJI bursts out laughing.

TOYIN: Which story did you want me to hear? That you got stabbed or that the molue tipped over Eko Bridge? Try that again and you will see my bad side. (*To SOJI.*) Is this amusing you? You think this is a fancy dress ball?

SOJI: I'm celebrating the release of K K/

TOYIN: Shut up!

YINKA: (*Serves himself.*) You're lucky he wasn't dressing like Fela. He'd be in his underwear.

YINKA digs in. TOYIN glares at him. He puts down his fork.

TOYIN: (*To HELEN.*) Turn off that music.

HELEN turns off the music. They bow their heads in prayer.

(*Prays.*) Father, for that which you have blessed us with, open our eyes to show our gratitude. Amen.

YINKA: Amen.

TOYIN: Soji!

SOJI: (*Reluctantly.*) Amen.

They eat. YINKA wolfs down his food. He shields his plate with his arm.

Yinka, the armed robbers have gone.

25 Luxurious bus.
26 Bus. Needs to be seen to be believed.

YINKA: I'm hungry.

TOYIN: No talking at table. Yinka, you're not in your hostel.

YINKA: I'm hungry!

TOYIN: Are you shouting at me? Is this what they teach you in Odogbolu? Remove your arm!

YINKA removes his arm from around his plate.

HELEN enters with a jug of water. YINKA's eyes trail her as she goes into the kitchen.

YINKA: You'll go through all the house helps in Lagos until no one will want to work for you.

TOYIN: Maria was useless. And a thief.

SOJI: You don't know for sure that she stole that bracelet.

TOYIN: Who did?

YINKA: Maybe Soji stole it to fund his revolution.

SOJI: Shut up.

TOYIN: Language!

SOJI: He called me a thief!

YINKA: Where did you get her from?

TOYIN: The usual broker.

YINKA: How old is she?

TOYIN: Why do you want to know?

SOJI: Is it true that you are going to become Chairwoman of Better Life?

TOYIN: Where did you hear that from?

YINKA: You should go for it. You can throw all those fat contracts Dad's way.

TOYIN: We do not need that kind of money.

SOJI: Exactly.

YINKA: Everyone who can is getting contracts from this government.

TOYIN: We are not everyone.

AFOLABI enters with CHIEF ADEYEMI's briefcase. CHIEF enters, weary. YINKA and SOJI stand up. AFOLABI puts down the briefcase and exits.

YINKA: Welcome Dad.

SOJI: Welcome Dad.

CHIEF: (*To SOJI.*) Immediately you finish eating, get those rags off, or I'll burn them with you inside them.

CHIEF sits down at the table. YINKA and SOJI sit down and continue eating.

(*Scoops food into a plate.*) Why aren't you in your dorm?

YINKA: I've come home early for Mum's birthday.

CHIEF: Don't you ever come back to Lagos without my permission.

TOYIN: You heard about the Smiths?

CHIEF: Yes.

TOYIN: You have to hire security for the house.

CHIEF: It didn't do the Smiths any good.

TOYIN: It's better than nothing… How was your appointment?

CHIEF: General Abubakar said he would reconsider the licence renewal.

TOYIN: You spent the whole time with General Abubakar?

CHIEF: You should have seen the waiting room. Filled with a who's who of Nigeria. I had to wait my turn. Even that televangelist Billy Robertson was there.

TOYIN: These Pentecostals are springing up everywhere. What does he want a license for?

CHIEF: Maybe NEPA supplies power to Heaven. God needs diesel for his generator. (*Gives TOYIN a business card.*) He's building a cathedral. I can supply him with materials.

TOYIN: I hope he does not want you to attend his church.

CHIEF: (*Looks straight at YINKA.*) Ah well. If you can tell me how to replace an oil licence…

YINKA averts CHIEF's gaze.

TOYIN: General Abubakar said he is reconsidering. That does not mean he's cancelling it.

CHIEF: I don' know what anything means any more.

TOYIN: You will feel better when he gets back to you. He knows who we are.

CHIEF: When everything is given to you, you don't need to consider the consequences of your actions.

YINKA: I was telling Mum to take the Better Life job so you don't have to keep coming up to Shagamu all the time.

TOYIN: What do you mean, 'all the time'?

CHIEF: It's nothing.

TOYIN: So why didn't you tell me?

CHIEF: Because it was nothing!

TOYIN: (*To YINKA and SOJI.*) Go upstairs.

They go upstairs.

CHIEF: There was a business opportunity.

TOYIN: A business opportunity or just an opportunity?

CHIEF: This is why I didn't want to tell you.

TOYIN: If your word means nothing anymore at least have respect for me. Have respect for your son's feelings.

CHIEF: Did Yinka complain that I hurt his feelings?

TOYIN: Of all the federal government colleges why Odogbolu?

CHIEF: You think I would jeopardise my son's future? You think I would transfer him to a school in his final year to suit my own purposes? It was either he got transferred or he would have been expelled. In fact you caused the whole problem.

TOYIN: Me?

CHIEF: Yes, you! If you weren't always showing contempt for the soldiers he would never have slapped General Abubakar's son.

TOYIN: The boy was rude to him. Juniors should respect their seniors.

CHIEF: Yes but his father is now Minister for Petroleum so there!

TOYIN: You think he won't renew your licence because of that?

CHIEF: You don't know these people. (*Stands up.*)

TOYIN: This business in Shagamu, what was it about?

CHIEF: Nothing came of it.

TOYIN: You have no shame.

CHIEF: How far is Shagamu to Odogbolu that I shouldn't drop by to see my son?

TOYIN: You used to be a man of honour.

CHIEF: And what am I now?

TOYIN: You tell me, Lanre.

CHIEF: No, Toyin. You tell me. In fact what does honour buy? Does it pay for your clothes? Does it maintain this house? Does it pay for this? (*Mashes the food on his plate.*) Or does it stop your son being transferred to another school on account of a small altercation? What does it pay for, Toyin? You behave like a queen but I'm the one who has to mind the business when the government launches a scheme today and closes it tomorrow. To get my money back I spend forever coming and going from one office to another. Then they bring out a similar scheme only it goes by a different name. I sign a contract with a minister in the morning, in the afternoon his replacement tears it up. So tell me if I can afford to be honourable so that I do not offend you. Tell me when I can have support in my own house for being pulled here and there by boys half my age. (*Heads for the stairs.*)

TOYIN: Did you see her?

CHIEF: I only saw our son. So what if I did?

TOYIN: From now until after my birthday no more evening appointments.

CHIEF: You must be joking.

TOYIN: You will no longer work weekends.

CHIEF: I will not be a prisoner of this marriage!

TOYIN: You still remember we are married. (*Stands up.*)

CHIEF: Toyin/

TOYIN: Either you agree or I turn down the Better Life job.

CHIEF: … And you will take the job?

TOYIN: My word means something.

CHIEF: (*Sensually.*) This morning. You wanted to tell me something.

TOYIN: Don't forget we are visiting my brother tomorrow after church. Helen!

CHIEF is surprised by the rebuff.

HELEN: (*Off.*) Ma! (*Enters and clears the dishes.*)

TOYIN exits upstairs. CHIEF waits a while, then goes upstairs.

HELEN goes back into the kitchen with some of the plates.

PAKIMI enters. He puts the car keys on the table.

HELEN enters. Pause.

PAKIMI: I just need more time. Please.

HELEN continues clearing the table.

Haba, why are you doing me like this? Because of money?

HELEN: No romance without finance.

PAKIMI: I will get the deposit. It is only time it will take. Just until after the party. You will see. I will... Helen!

HELEN exits into kitchen.

PAKIMI waits. He exits through the front door.

YINKA appears on the landing. He creeps downstairs, fondling his crotch.

HELEN enters. She steps back in surprise at seeing YINKA.

YINKA: Hi.

HELEN: Good evening, Brother, Brother...

YINKA: Yinka. How do you find it working for my mother?

HELEN: Very good. She is good madam.

YINKA: (*Laughs.*) Oh yeah?

HELEN: I bin wan' ask you before.

YINKA: (*Eagerly.*) Yeah?

HELEN: You get craw-craw?[27]

YINKA: No. Why?

HELEN points at his crotch. YINKA stops fondling himself. HELEN goes to the table. YINKA touches her bottom.

HELEN: Brother Yinka!

YINKA: What?

HELEN walks past him. YINKA touches her bottom again.

HELEN: Hey! I no be harlot.

YINKA: I'm sorry.

HELEN: Small boy like you come dey…

YINKA: I'm not a small boy! Don't you ever call me that.

HELEN: Wetin make I call you?

YINKA: (*Brings out money.*) You want a guy who can support you in these hard times. Who will you take your chances with: the heir to a fortune or a common driver? Going, going…

HELEN grabs at the money. YINKA withholds it from her. HELEN puts on the radio. Music: Fela Kuti's 'Lady'. She dances. She backs into him. YINKA is knocked off balance. She puts his hand on her breast. He rubs her body crudely.

HELEN: No sandpaper me now! You be carpenter?

HELEN gently guides his hand up and down her body. YINKA gets more aroused. He throws her onto the sofa and is about to jump on top of her.

Ah!

YINKA: What?

HELEN: Na outside di swimming pool dey. You sure say you don do dis before?

27 Scabies.

YINKA: (*Defensive.*) Yes.

HELEN: (*Guides him onto her gently.*) Easy. Like this.

> *YINKA tries to take her clothes off while he is on top of her. Her dress gets stuck over her head.*

HELEN: (*Her dress over her head.*) Comot am!

YINKA: Sorry!

> *YINKA yanks the dress off her. They fall off the sofa.*

HELEN: Ah!

YINKA: I'm sorry. (*Gives her the money.*) Please don't tell anyone. (*Heads upstairs.*)

HELEN: Soji dey your room?

YINKA: No he's gone to bed. Why?

> *HELEN secures the money in her blouse. She takes YINKA by the hand and leads him upstairs.*
>
> *SOJI comes downstairs and looks in their direction, disbelieving.*

SCENE SIX

The following morning. AFOLABI and PAKIMI in the kitchen stacking drinks. Their discussion takes place offstage.

PAKIMI: (*Sings.*) 'Money good, oh. Money good oh.'

AFOLABI: Your 419 never do you?

PAKIMI: This is not 419.

AFOLABI: Bank that is giving you forty per cent interest up front. That is wonder bank.

PAKIMI: They are genuine! Two of their board members are generals.

AFOLABI: All your money is 419.

PAKIMI: Those boys driving V-boot and building duplex in Lekki, how did they get their money?

AFOLABI: Not everybody is like you.

PAKIMI: Everybody is a hustler except you. When I visit Chief in my Frontera, you will open the gate for me.

AFOLABI: Aiye re ko ni da.[28]

PAKIMI: Jealousy. (*Sings.*) 'If you get money, make you laugh the people wey no get'.

AFOLABI: Shut up and carry, jo! Is Helen I feel sorry for. You will disappointment her again.

PAKIMI: Afolabi ro ra pelu oyinbo![29] I'm not wearing my bulletproof.

HELEN dashes downstairs, fixing her hair. Frantically she clears the dishes from the night before. PAKIMI enters.

Helen? Ah, no be last night's dinner be dis?

HELEN shoves dishes into PAKIMI's hands.

HELEN: Help me. Quick! Before Madam come down!

PAKIMI: I told you I would find a way.

HELEN: Put the plate for kitchen!

PAKIMI shows her a wad of cash. HELEN stops.

PAKIMI: I withdrew all my money and put it in Forum Bank. This is forty per cent interest upfront. By weekend I will get half the deposit.

HELEN hugs him, overjoyed.

I told you. I will do anything for you.

HELEN: (*Brings out the money from her blouse.*) Put this for your account.

28 A terrible life awaits you.
29 Easy with your English.

PAKIMI: Where did you get this from?

HELEN: (*Stretches her back.*) Na my life saving.

PAKIMI: I can do this by myself.

HELEN: I no wan' Madam party meet us for here. She will not beat me again.

PAKIMI takes the money. He exits. HELEN looks after him with pride. A noise from upstairs. HELEN frantically clears up. TOYIN come downstairs dressed for church.

TOYIN: Ah, are these the dishes from last night?

HELEN: Sorry Ma.

TOYIN: I haven't given you anything to feel sorry for yet. (*Points to the sofa.*)

HELEN brings out the koboko and hands it to TOYIN.

YINKA and SOJI come downstairs also dressed up. YINKA waits for SOJI to intervene. SOJI looks away.

YINKA: Mum! Please.

TOYIN: (*To HELEN.*) I will deal with you later.

HELEN exits to the kitchen.

YINKA puts the koboko back.

CHIEF: (*Coming downstairs.*) Um, after service I have a meeting at the club with Archbishop Robertson.

TOYIN: Baba Yinka…

CHIEF: I will come straight home. I promise.

TOYIN: I told you we are visiting my brother after service.

CHIEF: Is he not coming to your birthday? I will see him then.

TOYIN: Oya, let's go. You know what the traffic in Breadfruit is like.

SOJI: What about breakfast?

TOYIN: You'll eat at your uncle's house.

CHIEF: One second. I need to call the security company. (*Goes to the phone.*)

TOYIN, YINKA and SOJI exit.

CHIEF: (*Puts the phone down.*) Afolabi!

AFOLABI: (*Off.*) Sah! (*Enters.*)

CHIEF: Did you get her?

AFOLABI: She is in the backyard, sah.

CHIEF hands him some money.

AFOLABI: Ess sah, about Ikililu.

CHIEF: When I return. Open the gate. Make sure she's gone by the time we're home.

They exit.

HELEN enters. She cleans up.

AFOLABI enters with ONIJUJU. ONIJUJU surveys the house. She shakes her whisk at the four corners of the room and makes incantations.

HELEN: Mr Afolabi, who be dis?

AFOLABI: Sh!

ONIJUJU: (*Finishes her incantations, gives AFOLABI a packet.*) Every night scatter this powder inside the house and outside. No armed robber will enter.

HELEN: What if they have juju of entry to house which have juju?

ONIJUJU: This juju will counteract their counteraction. They will jump up and crow like cock.

HELEN: No be magun[30] be dat?

30 Charm used to punish an unfaithful partner.

ONIJUJU: This is two in one juju. I hope none of you has cheated on your partner?

HELEN takes a step back. AFOLABI carefully returns the packet to ONIJUJU.

HELEN: Ah, Mister Afolabi, you too?

AFOLABI: Shut up!

ONIJUJU: (*Gives AFOLABI another packet.*) This one is juju olorin. If armed robber step your door, he will drop his gun and begin to dance. He will sing every Sunny Ade song, side A and side B.

HELEN: What if he doesn't hear Sunny?

ONIJUJU: He will sing Barrister.[31] Go and scatter it around the house.

AFOLABI exits.

What of you? Can I help you with anything?

HELEN: No, oh.

ONIJUJU: I have love medicine powder. Rub on your face. Order any man he will obey you. I have used it myself four times.

HELEN: I don't need your love medicine. My man already love me.

ONIJUJU: Really?

HELEN: Yes, oh. He is ready to die for me.

ONIJUJU: You are a witch! (*Brings out a snail shell.*)

HELEN: No! I no be witch oh!

ONIJUJU: You marry oyinbo?[32]

31 Fuji musician.
32 European.

HELEN: No.

ONIJUJU: No blood transfusion?

HELEN: My man is hundred per cent Nigerian.

ONIJUJU: They are like that at first. They will do 'love one-tin-tin'. Give them one month.

HELEN: Not my man.

ONIJUJU: You didn't hear me say I've travelled that road four times? Husband number five is starting his own nonsense. The way I'm seeing his future… You need anybody you want to poison? Everybody has enemy.

HELEN looks at TOYIN's picture. She hesitates.

(*Brings out a packet.*) Put this in the food. By tomorrow morning the person will pafuka.[33]

HELEN: I no want.

ONIJUJU: (*Gives her his card.*) In case of incasity. (*Exits.*)

HELEN puts the card in the bin and heads for the kitchen. She turns round and retrieves the card.

SCENE SEVEN

That evening. An exclusive members club. CHIEF ADEYEMI with ARCHBISHOP BILLY ROBERTSON. He is dressed in expensive robes and speaks in a faux American accent, pronouncing God as 'Gad'. A waiter puts drinks in front of them and exits. CHIEF ADEYEMI is bantering with a club member who is offstage.

CHIEF: So if I ask you for only two million, you can't give me? Ijebu![34] (*Laughs.*)

ROBERTSON: Ah, is that not Chief Ogunbanjo of Ogunbanjo Enterprises?

33 Die, finish.
34 Subdivision of the Yoruba. Stereotyped as being stingy.

CHIEF: Yes. (*To another member.*) Major Orkar! Nice to see you. I hope you are not plotting coup. You say? (*Laughs.*)

ROBERTSON: Thank you for letting us meet in your club. It is not every day that I sit with a luminary in the midst of luminaries.

CHIEF: That's all right.

ROBERTSON: Chief. Nigeria will always be a land of opportunity even for the humble. Why because Gad has ordained it.

CHIEF: The meek shall inherit the earth.

ROBERTSON: Exactly! I was a jungle boy living on the streets of Benin. My parents could not feed me. They could not control me. Ah, Chief, I've not told anybody: I was one of Lawrence Anini's[35] gang. Yes! I was there when he shot off the police commissioner's nose. One of his nostrils landed in my lap. But look at me today. Look at me by the grace of Gad – Almighty, El Shaddai, Yours be the glory. Chief! You cannot change your life except you let the Holy Spirit kidnap you.

CHIEF: I suppose being an ex-armed robber you would know.

ROBERTSON: Chief, I must tell you that your Anglican church is a dead church. Ah! I was in London last month. Come and see empty pews.

CHIEF: Uh-huh, Uh-huh.

ROBERTSON: My members, they will tell you that Gad resides in my church. They will tell you how Gad has changed their lives. Some of them checked out of Nigeria. Big professors going to UK to clean windows, drive mini cabs and do all other sorts of menial jobs. One doctor had been a carer for so long she could tell the anus of a Lewisham quadriplegic from that of a Tooting paraplegic by touch alone! But Gad has given me the trumpet to call them back

35 Notorious armed robber.

to the Promised Land, back to the land flowing with moin moin[36] and akamu.[37]

CHIEF: Yes, moin moin and akamu.

ROBERTSON: Chief! Faith is the new oil. No! It is better than oil because faith never dries up! People are always searching for answers. The cathedral that I will build at Mile 12: one thousand capacity. Already I have to include an extension! That is how fast my church is growing and you must be a part of it. The Lord says you must be part of it. You must! Ah! Let me ask you Chief, if you don't mind: did you get your licence renewed?

CHIEF: No.

ROBERTSON: I thought as much.

CHIEF: Oh. Did you see it in a vision?

ROBERTSON: No. When you were in the General's office, I'm sure I heard begging and crying.

CHIEF: Oh no, that was not me. You must have been possessed by the Holy Spirit.

ROBERTSON: Ah. Did General Abubakar tell you why he did not renew your licence?

CHIEF: Quota system.

ROBERTSON: Quota system did not stop me from getting a license. And I know six people from Bendel State who got a license. Even my colleague who is from Onitsha but is claiming Auchi, he got a licence!

CHIEF: You got a license?

ROBERTSON: The General's PA is my church member. He came to me with a problem no one else could solve and

36 Bean cake.
37 Cornmeal.

this is how our Father – Almighty, El Shaddai, Yours be the glory – saw it fit to reward me for helping him.

CHIEF: About your cathedral. My company can supply you with the best materials at a favourable price. Italian marble, English oak.

ROBERTSON: Chief. You know Dayo Cole? He's my church member. I'm in negotiations with him.

CHIEF: He stocks local materials. When you see my catalogue you will understand what I'm talking about.

PAKIMI enters with CHIEF ADEYEMI's briefcase.

How long does it take you?

PAKIMI: (*Hands CHIEF the briefcase.*) You have phone call, sir.

CHIEF: Just a moment, please, Reverend. (*Hurries out.*)

PAKIMI nods to ROBERTSON.

ROBERTSON: Brother. Are you a Christian?

PAKIMI: Sometimes.

ROBERTSON: It's either you are a Christian or you are not.

PAKIMI: 'Cele'.[38]

ROBERTSON: You should come to the real church. Divine revelation awaits you.

PAKIMI: Can your revelations give me forty per cent interest?

ROBERTSON: (*Laughs.*) You put your stock in earthly banks when the Lord offers the greatest returns.

CHIEF returns.

CHIEF: Sorry, oh. My wife has me on curfew. She thinks I go looking for bush meat.

ROBERTSON: I don't understand.

38 Short for Celestial Church of Christ.

CHIEF: You know, bush meat.

PAKIMI: The type you cannot use toothpick to remove.

CHIEF: Who is talking to you? Go and wait by the car. Idiot!

PAKIMI saunters out.

ROBERTSON: (*Finally gets it, laughs.*) Oh, I get you, Chief.

CHIEF: What I mean is I cannot stay too long but (*Opens his briefcase.*) have a look at these and tell me if they are not fit for the house of the Lord?

Commotion.

CHIEF and ROBERTSON dive under their chairs.

PAKIMI enters stricken.

Pakimi what is it? Is it a coup?

PAKIMI: Sah, I have to go to bank, sah, please!

CHIEF: Pakimi! Have you gone mad?

PAKIMI: (*Crazed.*) Please sah! (*On his knees, holds CHIEF's feet.*) Please, sah!

SCENE EIGHT

That evening. The Adeyemi sitting room. AFOLABI and HELEN put up the decorations for the party. YINKA steals a smile at HELEN. HELEN affects a smile in return. YINKA and SOJI are watching the Nigerian video film. SOJI is unimpressed. YINKA is into it.

VIDEO: To God be the glory. Stay tuned for Part Six. (*Music.*)

SOJI: Jesus Christ. This is crap.

AFOLABI stumbles over SOJI's outstretched legs.

Sorry, Mr Afolabi.

YINKA: (*To SOJI.*) It's all right man. (*Changes the video.*)

SOJI: Hey put on Rambo.

YINKA: Shush! Part Six is about to start.

SOJI removes the video from the player and is about to insert the Rambo video.

Leave it in there!

They tussle with each other, bumping into AFOLABI.

AFOLABI: Oh Lord! Oya, watch it upstairs and allow us to finish.

YINKA switches off the TV, snatches the Nigerian video from SOJI and races upstairs.

SOJI: (*Chases after him.*) I'm not watching it, Yinka.

HELEN and AFOLABI decorate the house. HELEN puts on the television.

AFOLABI: Helen!

HELEN: Make we hear news.

AFOLABI: If Madam catch you!

HELEN: No be the brothers leave am on?

AFOLABI: Kill the television.

HELEN ignores him. AFOLABI heads for the television.

HELEN: I go tell Madam say you touch the television.

AFOLABI: I don't know you are crafty like this.

HELEN: Government say we must be informed. I dey do my duty as good citizen.

AFOLABI: Is *Checkmate* you want to watch.

Music for Checkmate.

HELEN: (*Disappointed.*) Oh, e don finish.

AFOLABI: (*Chuckles.*) Is it not news you want to hear as a good citizen?

Music for the news comes on.

NEWSCASTER: Tonight's headline. The Federal Government closes Forum Bank.

HELEN: (*Shaken.*) Ehn?

AFOLABI: Hepa!

NEWSCASTER: … A government spokesman said the bank's dealings are under investigation. The bank's director had stolen all the deposits prior to the police raid. His whereabouts are unknown.

AFOLABI: You see? I tell your man. He have throw his money away. God has catch him…

HELEN feels faint.

Helen, are you OK?

A noise at the door. HELEN recovers and switches off the television.

CHIEF and PAKIMI enter.

Welcome sah!

CHIEF: (*Wearily.*) Ehen. (*Goes upstairs.*)

AFOLABI: (*Starts to sing.*) 'If you get money make you no laugh the people wey no get.'

PAKIMI: God punish you.

AFOLABI: You that your own curse have work, don't curse people, oh, maybe the curse on your head still remain.

PAKIMI: (*Picks up the vase.*) I will smash this on your stupid head!

AFOLABI: If you damage that vase…

HELEN comes between them.

HELEN: Una don craze? (*Takes the vase away from PAKIMI.*) Mr Afolabi, make you dey go. I go finish the remaining. Oya!

AFOLABI: (*Exits, singing.*) 'If you get money, make you no laugh the people wey no get…'

PAKIMI: You heard the news.

HELEN: Any money remain?

PAKIMI: No.

HELEN: At all?

PAKIMI: I promise, before the end of this year… (*Holds her.*)

HELEN disengages from him.

HELEN: See the time. You no go see transport go your house.

PAKIMI: Helen…

HELEN ignores him and decorates the house.

PAKIMI exits.

YINKA comes downstairs. He grabs HELEN by the waist.

YINKA: Everyone's asleep. (*Tries to kiss her.*) Are you crying?

HELEN: (*Dries her eyes.*) Na pepper.

YINKA: Come. (*Leads her upstairs.*)

HELEN: I get headache.

YINKA: When I hit you with my double barrel/

HELEN: I no dey joke.

YINKA: I see your game. That's cool. (*Brings out money.*)

HELEN: I no be harlot.

YINKA: OK then what do you want?

HELEN: I wan' my freedom. I wan' future.

YINKA: Is that all? (*Offers his hand.*)

HELEN hesitates. She puts up the last decoration near TOYIN's picture and goes with YINKA.

SCENE NINE

The following day. The sitting room.

CHIEF ADEYEMI and TOYIN reading through the birthday cards.

TOYIN: (*Opens a card.*) First Mrs Okomile invites herself and now Archbishop Robertson?

CHIEF: This one's from 'Bidemi: 'To my darling sister. Wishing you another fifty glorious years'. You must have sent her allowance. A pity she didn't marry someone like me.

TOYIN: Helen!

CHIEF: No. We are having breakfast in the garden.

TOYIN: Thanks.

CHIEF: For what?

TOYIN: For keeping to your word.

CHIEF: If you want to ruin this moment/

TOYIN: (*Passionately.*) You don't know how much it means to me. My husband.

TOYIN leads CHIEF out by the hand.

CHIEF: (*Points to upstairs.*) We're going the wrong way.

TOYIN hits him playfully.

AFOLABI enters. CHIEF gives him money.

AFOLABI: (*Stunned by the amount, salutes.*) Sah!

He leads CHIEF and TOYIN through the kitchen. TOYIN leaves her handbag behind.

SOJI and YINKA come downstairs.

SOJI: But you said you had money.

YINKA: And now I don't have any.

SOJI: We can't just give her a card and kisses.

73

YINKA sees TOYIN's handbag.

Bobo![39]

YINKA: She won't know anything's missing. (*Holds up a wad of cash.*) How much? Quick!

SOJI: You took Mum's bracelet.

YINKA: Maria took it. They found it on her.

SOJI: Then why did she say that you gave it to her?

YINKA: You're the only one who believes her. Shows what a brother you are.

SOJI keeps his gaze on YINKA.

What? Mum would have sacked her anyway.

SOJI: Jesus Christ, Yinka! She spent two weeks in a police cell.

YINKA: She got what she deserved. Who the hell is she?

SOJI: Are you going to give Helen a bracelet too? I know about you two.

YINKA: So what if you know? You will tell? Stop looking disgusted! You, 'Che Guevara', you wouldn't dream of doing it with Helen.

SOJI: I wouldn't take advantage of her.

YINKA: Because of what she is. Half the guys in my dorm lost their cherries to their house-girls. Guys will be hailing me, you stupid virgin.

SOJI: I'll tell your old friends.

YINKA: I don't care about them anymore.

SOJI: I'll still tell…

YINKA shoves him.

39 Mate.

Hey!

YINKA shoves him again. He falls onto the sofa. YINKA holds his neck.

Yinka!

YINKA: Tell and I'll brush you so bad, Mum won't recognise you.

SOJI: OK! I won't.

YINKA: (*Lets go.*) You wouldn't last one second in my dorm. Talk according to your muscle. That's the law. Any fucker can chance me out of my dinner because he's bigger than me. Dad can pay their parents' salary ten times over but who gives a damn that I'm Chief Adeyemi's son?

SOJI: You said you were settling down.

YINKA: I was! I was becoming a happening guy. But what does your old man do? He impregnates the school cook. The school cook! And he can talk to me about being handed everything.

SOJI: You did it on purpose. Mentioning Dad going to Shagamu. Jesus Christ, Yinka!

YINKA: Yes! I did it on purpose! She should know the kind of man he is.

SOJI: You think she doesn't? You could have waited until after her birthday.

YINKA: What difference has it made? One day she's going to catch him in the act. I want to be there looking him straight in the eye. I want to be there when he pays.

SOJI: That's not his wallet.

YINKA puts the money back into TOYIN's handbag.

HELEN enters.

HELEN: Madam is calling you. She want her handbag.

YINKA: I've got it, babe.

SOJI looks at YINKA and exits.

YINKA takes some money and pockets it. He smacks HELEN on the bottom as he exits.

HELEN makes sure the coast is clear, brings out ONIJUJU's card and phones.

HELEN: Baba Onijuju… Yes, na me. Helen from Chief Adeyemi's house. About that love medicine…

End of Act One.

Act Two

SCENE ONE

The party in full flow. PAKIMI, HELEN and AFOLABI serve the guests. HELEN keeps getting sprayed by the rich guests. PAKIMI rushes over to the guests but they ignore him. Even AFOLABI is given a few notes. CHIEF ADEYEMI and TOYIN dance to Ebenezer Obey's 'Happy Birthday'. The music changes to Nico Mbarga's 'Sweet Mother'. CHIEF ADEYEMI relinquishes TOYIN to YINKA and SOJI. CHIEF ADEYEMI dances sexily with MRS OKOMILE. TOYIN watches them concernedly as she receives well wishers. HELEN ushers in REVEREND BILLY ROBERTSON. ROBERTSON greets TOYIN. HELEN pockets money from a guest. MRS OKOMILE waits. CHIEF signals to her that he will catch up with her later.

ROBERTSON: It's a wonderful party Chief.

CHIEF: Thank you.

ROBERTSON: As a present to you and Madam, I am awarding you the contract.

CHIEF: You're not going with Cole?

ROBERTSON: The house of Gad deserves only the best.

CHIEF: (*Pumps his hand.*) See you in service.

SOJI enters.

ROBERTSON: Bring your sons. I'm sure they will love it.

CHIEF: Soji! Have you said hello to Reverend Robertson?

SOJI: Hi.

CHIEF: Is that how to greet?

ROBERTSON: Don't worry Chief. It is how young people talk.

CHIEF: Those from the gutter.

AFOLABI enters.

AFOLABI: Sah, General Abubakar is here.

CHIEF: One moment, Reverend. (*Exits with AFOLABI.*)

ROBERTSON: When you come to my service/

SOJI: We go to St Paul's.

ROBERTSON: Try us one Sunday. You'll be surprised what miracle awaits you.

SOJI: You mean your so-called miracles.

ROBERTSON: Excuse me?

SOJI: And your sermons. You preach that poverty is ordained from on high. You tell people that prayer is the only solution. How is that going to save Nigeria?

ROBERTSON: Anyone who places faith in their own strength is doomed to failure. Not by your own might. Only Gad can save Nigeria.

SOJI: And how long is 'Gad' going to take? Or are we not a priority for the God of Israel?

ROBERTSON: Life's mysteries can only be revealed through divine revelation. And it is good that a young man like you is asking questions. For it is only if you seek that you will find. Most of our members are young people like you.

SOJI: I've heard about your 'love feasts' that you use to bribe hungry students/

ROBERTSON: I do not like that word 'bribe'. I would say we entice them away from their usual vices.

SOJI: Sounds like a bribe to me.

ROBERTSON: The choice was theirs to join my church. In fact most of them stay with us long after they graduate.

SOJI: I wonder how many of them leave when they see how many times you pass round the collection bucket.

ROBERTSON: Gad loves a cheerful giver.

SOJI: He has to, to keep you this well-dressed.

ROBERTSON: My Gad is not a poor Gad. Would you prefer that I wear sackcloth?

SOJI: And I suppose he spoke to you in a vision that you must own four limousines?

ROBERTSON: Should I reject my Lord's blessings?

SOJI: Why does he choose to reward you so richly when majority of your flock are suffering? You're not blind to the tragedies that pass you on the street. You're no better than the soldiers who keep us in bondage with their guns. You do it with false promises. You're nothing but a 'Brother Jero'.

ROBERTSON: You who has never known poverty, you want to preach to me. I was roaming the streets hungry while your father and his friends were eating the national cake like there was no tomorrow.

SOJI: So you've come for your share.

ROBERTSON: I'm just a man trying to make it in this world like everybody else.

SOJI: By selling your people to a foreign god.

ROBERTSON: (*Grabs SOJI by the neck.*) And how did your father make his money? Was it not on the back of import license? Even candles he brought in. Anyone who made products locally he made sure he ruined that person. My father grew rice but your kind treated it like it was poison. You ate only 'Uncle Ben's'. This house, I bet you not one thing is made in this country and you want to prove to me, you this bloody aje butter. I will… (*Throttles SOJI.*)

CHIEF enters. ROBERTSON pretends to pray for him.

Father, heal my brother of his unbelief!

SOJI: Ah! Dad!

CHIEF: Ah, what are you doing?

SOJI: Dad! He's trying to/

CHIEF: He's an atheist. It will take more than that to convert him.

ROBERTSON: (*Whacks SOJI.*) Believe!

SOJI: Yah!

CHIEF: Ehen! One more! One more!

ROBERTSON: Believe!

SOJI: Jesus Christ!

CHIEF: Reverend! You have saved my son. Thank you. Thank you so much.

ROBERTSON: Thank the Lord of Abraham, Jacob and Isaac. Amen!

CHIEF: Amen! Thank you, Reverend.

ROBERTSON: Just doing my job as ordained by Gad, Chief. See you on Sunday, Soji. (*Exits.*)

CHIEF: He will be there! Have you said hello to General Abubakar?

SOJI looks away.

Outside. Now. (*Shoves SOJI ahead of him.*)

HELEN enters with a tray. She checks to see no one is around and brings out ONIJUJU's powder. She is about to powder her face when she hears people approaching. She dashes into the toilet.

TOYIN and MRS OKOMILE enter.

Ah, Mrs Okomile! How is the colonel? Still erect as ever?

MRS OKOMILE: Your party has really done our mother proud.

CHIEF: What else can we do? My birthday girl has a pleasant surprise for you.

TOYIN: I hope you haven't touched the pounded yam.

CHIEF: Actually, I was just about to go before I saw you.

TOYIN: Uh-huh.

CHIEF: (*Heads for the toilet.*) It's true now. (*About to open the door.*)

TOYIN: Baba Yinka…

CHIEF: Okay, I'm going. (*Exits.*)

TOYIN: Thank you for your gift.

MRS OKOMILE: Only the best jewellery is good enough for our mother. The First Lady sends her greetings. She is away on official trip to Switzerland along with the other governor's wives. If not we would have all been here in full force. She is getting you the finest damask for your present. That is in addition to a special gift from each of the governor's wives.

TOYIN: This Better Life is giving better life to some of us.

MRS OKOMILE: Once you become chairwoman, you will see how the benefits trickle down to our rural sisters. But most important you and Chief will get what you want.

TOYIN: Which is?

MRS OKOMILE: Oh come on, Ma. That is like me telling you your business.

TOYIN: No, please, tell me.

MRS OKOMILE: After all it is you civilians who taught the soldiers how to… Don't mind me, Ma. I'm talking rubbish. It's my euphoria at you accepting the post. It is for you to administer the programme as you please. When I present you to the First Lady, it will be the best birthday gift she has ever had.

TOYIN: Did I tell you that I had accepted the post?

MRS OKOMILE: I don't understand you, Ma.

TOYIN: I put it very clearly.

MRS OKOMILE: So what are you saying, Ma?

TOYIN: What do you think I'm saying?

MRS OKOMILE: You'd rather be the secretary of the Women's Society than the Better Life chairperson?

TOYIN: Do you think I would have ever considered otherwise?

MRS OKOMILE: You have put me in a situation with the First Lady. Chief said you wanted the post.

TOYIN: Did he tell you that while you were sleeping with him?

MRS OKOMILE: Ess, Ma!

TOYIN: You walk into my house fooling around with my husband.

MRS OKOMILE: Please Ma, I've never/

TOYIN: Then you tell me that I'm going to be a present to a girl that I'm old enough to be her big sister. Tell her and tell your cohorts that I want nothing to do with you. Now get out of my house.

MRS OKOMILE: (*Makes to leave, turns round.*) I remember my first day at school, how you humiliated me in front of morning assembly all because I did not wear the correct shoes. My parents worked day and night just to sew my uniform. They could not afford the sandals. You put me up as a 'shining example' of 'awon omo[40] free education', and how we were going to destroy your school with our alatika[41] behaviour. I was not surprised you left after the last set of your 'true grammarians' passed out. You couldn't

40 The children of.
41 Common.

stand the sight of us. Now we are in power and you still hold us in contempt.

TOYIN: Afolabi! Pakimi!

MRS OKOMILE: As for Chief: a man lives by the river yet he goes everywhere searching for water to drink.

TOYIN: How dare you! (*Raises her hand.*)

MRS OKOMILE: We are no more in school. If you slap me I will slap you back. I will so disgrace you in your life you will never forget it. Have a happy birthday. (*Exits.*)

CHIEF: Mrs Okomile! Has my wife... Mrs Okomile! (*Looks at TOYIN in askance.*)

TOYIN: Remember what today is and behave yourself. I want to dance with my husband. (*Exits.*)

CHIEF is bewildered.

Lanre!

CHIEF exits.

HELEN enters from toilet, shocked by what she has heard. She has powdered her face with the love medicine. She picks up her tray and exits.

The music changes to Fela's 'Zombie'.

PAKIMI and AFOLABI. AFOLABI whistles 'Money good oh' as he counts money.

PAKIMI: These useless rich men. They are only spraying girls. (*Makes to take some of AFOLABI's money.*)

AFOLABI: Kai!

PAKIMI: Just ten naira now.

AFOLABI: Find your own.

PAKIMI sees a head-tie and wraps it round his head.

What nonsense are you doing now?

PAKIMI: How do I look?

AFOLABI: Oni 'ranu.[42]

PAKIMI enters the toilet. He leaves the door open.

PAKIMI: Ah see. (*He shows AFOLABI the powder.*) Someone left talcum powder here. This is a sign from God. (*Throws powder all over his face.*) I beg check the sitting room, maybe someone dropped lipstick.

AFOLABI: 419 have turn your head.

PAKIMI: How much is in your hand that you are making noise? Ikililu is there waiting for you to do your job, you dey do su egbe.[43] You'd better find how you will get real money before he dies. Correct ni mo so fun e.[44]

AFOLABI: Plus the money Chief give me. It will reach.

PAKIMI: Naira is now five to one. Cost of medicine has doubled. What will you tell Ikililu next week when naira is six to one? Idiot.

AFOLABI: You are idiot to tell me that/

PAKIMI: Go and serve the guests! Servant.

AFOLABI: Who are you calling servant?

They approach each other, ready to fight when a rich drunk GUEST enters. PAKIMI saunters up to him and dances, shaking his bottom. The GUEST sprays PAKIMI with money. Aroused, the GUEST grabs at PAKIMI. PAKIMI pushes him away. The GUEST is insistent, groping PAKIMI. He throws PAKIMI onto the sofa and lies on top of him. PAKIMI shrieks. The guest pulls off PAKIMI'S head-tie.

GUEST: (*Realises PAKIMI is a man, jumps off PAKIMI.*) Ehn? A lady man! A lady man!

42 Foolishness.
43 You're behaving like a moron.
44 I'm telling you the right thing.

PAKIMI dashes out, followed by GUEST. AFOLABI pockets the money and quickly exits.

YINKA shoves SOJI into the room.

SOJI: Don't shove me! Why is everyone treating me like a kid?

YINKA: You think it is funny changing the music? You should have seen the look on General Abubakar's face.

SOJI: I did it for you! He won't give Dad his license back so why is that zombie and his son here?

YINKA: You heard that K K Folarin had arrived.

SOJI: I will show them… K K Folarin is here?

YINKA: Liar.

SOJI: I swear I didn't know he is here.

K K FOLARIN enters wearing an expensive agbada. SOJI is dumbstruck.

K K FOLARIN: Please, where is the toilet?

YINKA points to the toilet. Soji stares at K K FOLARIN in shock.

Thank you. (*Exits to the toilet.*)

YINKA: He's wearing it out of respect for Mum. We've got to wrap up Mum's present.

SOJI: You do it.

YINKA: Come on. (*Pulls him.*)

SOJI: (*Breaks free.*) Let go of me!

K K FOLARIN comes out of the toilet.

Mr Folarin?

K K FOLARIN: Yes?

SOJI: I'm sorry. I wasn't sure it was you.

K K FOLARIN: Oh. (*Holds up his agbada, laughs.*) This is the first time since I was a child that I've worn one. It's certainly the most expensive.

SOJI: But you're wearing it out of respect for our mother.

K K FOLARIN: Oh, you're Toyin's boys. Lovely to meet you. (*Shakes YINKA's hand. Offers his hand to SOJI.*) It will be announced tomorrow so I might as well. I've been appointed Chairman of the Taskforce for Rice Importation and Distribution.

SOJI: What?

K K FOLARIN: Quite a mouthful, isn't it?

SOJI: (*Does not shake his hand.*) But who is going to fight for the people?

K K FOLARIN: There are many ways to skin a cat.

SOJI: But you're joining them. The enemy of the people.

K K FOLARIN: If I didn't accept this post some corrupt bastard would take it. I can be a paradigm of good leadership. I met with Mr President and he spoke sense. He's a very intelligent man. He has great plans for the country. He needs people like me to help initiate them.

SOJI: But they are soldiers! Anyone who colludes with them is a traitor.

K K FOLARIN: They are human beings like us. Young man, we have a crisis of followership. You know how much I've sacrificed for this country, only to be betrayed by my own people and for how much? I'm not giving up the struggle. I'm engaging constructively with this government. I say to you, keep up the fight. Aluta continua. (*Shakes SOJI's hand and raises his arm in a black power salute. Exits.*)

SOJI's arm falls to his side.

YINKA: Forget him, man. Come on, Mum's bracelet. Before she cuts her cake.

HELEN enters with a tray. She smiles seductively at YINKA.

You're in no mood to be wrapping presents. Go get a drink. (*Pushes SOJI out. To HELEN.*) I'm digging this your powder.

HELEN starts blinking at him.

Have you got something in your eyes.

HELEN: Pick di duster, begin dust.

YINKA: What?

HELEN: Pick the duster.

YINKA: Have you gone crazy?

HELEN: You will marry me.

YINKA: (*Bursts out laughing.*) You didn't really believe me, did you?

HELEN: But you talk say/

YINKA: You're funny, oh.

HELEN: Of course I know say you dey joke.

YINKA: (*Waves money at her.*) Dance for me.

HELEN dances unenthusiastically.

What is this lady dance? Give me fire dance. Ah, wait.

YINKA turns on the radio to Wasiu Ayinde's 'Bobo No Go Die Unless To Ba D'arugbo' plays.

This is your music, isn't it?

HELEN continues dancing without enthusiasm. CHIEF ADEYEMI enters. He watches HELEN. CHIEF signals to YINKA to leave. YINKA quickly exits. HELEN oblivious continues dancing. She bumps into CHIEF.

HELEN: Ah! Sorry sah. (*Hurriedly picks up her tray.*)

CHIEF: Put it down.

HELEN: Sah?

CHIEF points to the table. HELEN puts down the tray.

CHIEF: (*Sits down.*) Continue.

HELEN: Sah?

CHIEF: Dance!

HELEN dances. A noise from outside. CHIEF turns round. No one comes in. He takes HELEN by the hand and leads her upstairs.

PAKIMI dashes through the house, chased by GUEST.

GUEST: Did you see him? A lady-man! Oh my God.

They exit.

TOYIN, YINKA, and SOJI enter with TOYIN's birthday cake.

Nico Mbarga's 'Sweet Mother' plays in the background.

TOYIN: Where is your father? Oya, somebody find my husband.

PAKIMI enters.

Check if Chief is still outside.

PAKIMI: Yes Ma. (*Goes back out, dashes back in and exits in the opposite direction.*)

GUEST: (*Off.*) I saw him here right now. A lady-man!

TOYIN: These candles will go out, ehn? (*To YINKA.*) Go and check if he's upstairs.

YINKA hesitates.

Quick! Or do I have to go up myself.

YINKA goes upstairs. He comes down and heads straight out the door.

Yinka!

TOYIN heads to the stairs. CHIEF and HELEN come downstairs. HELEN tries to cover up her dishevelled look.

PAKIMI dashes in. He sees HELEN and CHIEF ADEYEMI and stops in shock.

SCENE TWO

The sitting room. The birthday decorations are still in place. YINKA is by the foot of the stairs looking up attentively. SOJI watches.

SOJI: Can you hear anything?

YINKA: Sh! (*Goes up. Hears a noise and scuttles down backstairs.*)

SOJI: This is the last straw.

YINKA: She's not going to leave.

SOJI: Dad went too far this time.

YINKA: Then she would have left him long ago.

SOJI: She stayed because of us.

YINKA: Then she's staying.

SOJI: Get real, Yinka!

> *Yinka picks up the phone.*

> What are you doing?

YINKA: I'm calling Uncle Kunle.

SOJI: Don't call him!

YINKA: Who else do you know who can help? (*Grabs the phone.*)

SOJI: Mum won't want you telling everyone!

YINKA: Let go!

> *They tussle over the phone.*

> *HELEN enters with a broom.*

> You bitch. You're still here?

> *YINKA lunges at her. SOJI holds him back.*

HELEN exits.

Come back here, let me kill you!

SOJI: Behave yourself!

YINKA: I'll kill her. I swear to God I'll kill her.

SOJI: You went after her first.

YINKA: You're blaming me?

SOJI: Like father like son. Go back to Odogbolu!

YINKA: (*Grabs SOJI by the neck.*) Your stupid revolution gave her the wings!

They struggle violently with each other.

TOYIN comes downstairs.

TOYIN: Stop that right now!

They stop fighting.

Never lay a finger on each other – ever. Do you hear me? Now more than ever you must be each other's keeper.

SOJI: You can't go, Mum.

TOYIN: I'll be at your Uncle Kunle's in Ikeja. You can visit me anytime.

YINKA: (*Grabs her suitcase.*) This is your home!

TOYIN: Yinka, let go.

YINKA: I'll never disobey you. I'll be a good son, Mum. I'll be the best son for you.

TOYIN: You are the best two sons I could ever wish for.

SOJI: Then stay.

YINKA: Who should we call to help?

TOYIN: Hasn't your father broadcast my shame enough?

YINKA: You can't let him get away with it. He has to pay.

TOYIN: It's a man's world.

SOJI: You don't believe that, Mum.

TOYIN: Ah, well…

SOJI: You don't believe that!

TOYIN: I brought you up well. You will not turn out to be like your father.

YINKA: I'm coming with you.

SOJI: You can't leave us here.

TOYIN: You think I don't want you to come with me? I know your father. He will bring another woman in. It will be someone respectable so that he can keep up with his peers. No woman's child is going to claim their rights over you. This is your house. You must stay.

TOYIN prises her suitcase away from YINKA. SOJI grabs it.

(*Hugs them.*) My boys. My boys.

The brothers weep.

CHIEF comes downstairs. He stops when he sees TOYIN.

TOYIN: Don't worry. I'm waiting for Pakimi.

CHIEF: (*To the brothers.*) Go upstairs.

The brothers stay where they are.

CHIEF: Are you deaf? I say go upstairs!

The brothers do not budge. CHIEF picks up the whip from under the sofa and raises it.

TOYIN: (*Drops her suitcase.*) Touch my sons and both of us will die in this house today.

CHIEF lowers the whip.

Go upstairs.

Slowly, showing defiance to CHIEF ADEYEMI, the brothers go upstairs.

CHIEF: They are the children of their mother.

TOYIN: Thank God for that.

CHIEF: If you hadn't curtailed my movements this would never have happened.

TOYIN: That's your excuse for sleeping with my house girl on our matrimonial bed on my birthday?

CHIEF: That bed lost its meaning the day you moved into your own room.

TOYIN: So it is my fault that you have lost all sense of shame. Because you cannot sleep without someone beside you.

CHIEF: You know the kind of man I am.

TOYIN: And you know the kind of woman I am. I let you sleep around behind my back. I let you buy flats and houses for those stray cats. I turned a blind eye after the first harlot when I realised that screaming at you would only give me hypertension. After Odogbolu I sincerely thought you would come to your senses. I asked you to sheath your penis just for a few days. But you have no limit when it comes to parading your wrinkly skin in front of girls old enough to be your grand-daughter.

CHIEF: And who made my skin wrinkly? Was it not you with your pettiness? We must be the only people in Lagos who go to parties on full stomachs. For some stupid decorum that no one else notices. When you are in the midst of dancers does it make sense to stand still?

TOYIN: Only people of integrity quote proverbs.

CHIEF: Here we go! Put down after put down. Lanre, don't be bush. Lanre, don't be coarse. Lanre, that is conduct unbecoming of a gentlemen. I'm surprised we still eat amala with our fingers.

TOYIN: You really have no regrets for what you did.

CHIEF: You said it already. I have no shame.

TOYIN: Indeed.

CHIEF: It would never have happened if you had taken the Better Life job.

TOYIN claps her hands in amazement.

Yes! I moved heaven and earth to get you that appointment.

TOYIN: A job you didn't consult me on. You treated me like I was a piece of meat that you could sell to them of all people.

CHIEF: I did it for the family. I do a lot of things that I do not like but I do it for the family.

TOYIN: Am I not part of the family? Haven't I spent all my married life upholding our name, a name which you have stained many times over?

CHIEF: These people that you have such contempt for, they are in charge. I say it every day but you live in your own world.

TOYIN: What have they got to do with us?

CHIEF: They hold the purse strings. They build a factory in their village whether it makes sense or not. They give by who can kiss their feet or bribe them the most. They award themselves contracts through the backdoor. The rest of us are rats fighting for the crumbs that fall from their mouths. I am a beggar like everyone else. That job was my seat at the table.

TOYIN: Your companies don't need their contracts.

CHIEF: My name is founded on money. Without it I am nothing.

TOYIN: Your name is founded on money. Mine isn't.

CHIEF: You wouldn't be able to afford your precious dignity.

TOYIN: You took away my dignity when you slept with my house girl.

CHIEF: That is what hurts you, that I slept with Helen.

TOYIN: You slept with her in my house!

CHIEF: We are just going in circles. I've had enough.

TOYIN: I had enough long before you did. If not for the boys I would not have put up with you for this long.

CHIEF: You should have gone. It wouldn't have made any difference.

TOYIN: Kunle said I shouldn't marry a loose, uncouth man like you. He knew that I couldn't tame you.

CHIEF: I look like an animal that you can tame? That is your family all over. They never respected me.

TOYIN: Why would they respect a wife beater like you?

CHIEF: Why did you stay? You knew a catch when you saw one. The only village boy who got a scholarship among all you children of elites...

TOYIN: My father helped you!

CHIEF: I bore your brother's snide remarks in silence but look at me today...

TOYIN: Did you not trade on my family name?

CHIEF: The Adeyemi name is bigger than your stuck up family's!

TOYIN: I should have dumped you back in London.

CHIEF: I wanted to dump you! But I did the honourable thing. You stayed because of the children. Well I stayed full-stop! I should tell them the kind of woman you really are. You will do anything at all costs for propriety and you claim

that you know what love is. Do you really love those boys?
You've spent all your life in a corset...

TOYIN heads for upstairs. CHIEF ADEYEMI bars her way.

Where do you think you are going?

TOYIN tries to push through. CHIEF ADEYEMI stands his ground.

TOYIN: Yinka! Soji!

CHIEF: You are not taking my sons.

TOYIN: If you think I'm leaving them with you, my name is
not Toyin Ogundele.

CHIEF: They are not Ogundeles. They are Adeyemis.

The boys come downstairs.

TOYIN: Pack your bags.

CHIEF: Stay where you are.

TOYIN: I said pack your bags!

CHIEF: If you move... You had your chance to leave with your
head held high. You don't get out of my house I will throw
you out.

TOYIN: I dare you.

CHIEF: Toyin, I will not tell you again!

YINKA and SOJI are in anguish at the scene.

TOYIN: What will you do? You will beat me again/

*CHIEF slaps TOYIN and drags her out by her hair. He picks up her
suitcase and throws it out and rages after her. We hear TOYIN's
screams and CHIEF's bellowing.*

CHIEF: Don't you ever step foot in this house! You or your
bloody brothers! I will kill you and kill them! I am Chief
Olanrewaju Adeyemi. There is nothing any of you can do
to me! Nothing! I am the man of this house!

The boys look on in horror, too shocked to move. CHIEF enters.

Get to your rooms!

They stand still.

CHIEF gets the whip from under the sofa and charges up the stairs. The brothers run off. CHIEF comes downstairs. AFOLABI enters in shock.

If she sets foot on my estate you are fired!

AFOLABI nods sadly.

What?

AFOLABI: Yes sah!

CHIEF: Lock the gate then call Helen.

AFOLABI exits.

CHIEF puts on the TV. The voice of Billy Robertson. PAKIMI enters. He puts the keys on the table. As he heads towards the kitchen door he stops and listens.

ROBERTSON: (*Voice only.*) Only Gad can save Nigeria. Only Gad can solve your problems! Those of you who toil in vain, seeking a way out. Those of you who are seeking solutions to life's up and downs, there is only one way and that is through Jesus Christ our Lord. There is only one path to prosperity and you can walk it. It doesn't matter if you are rich or poor. It doesn't matter your circumstances. Call on Jesus. Accept him into your life. This is a time of abundance for believers. All you have to do is kneel down and pray. Kneel down and accept Jesus into your life. Kneel!

PAKIMI kneels down.

HELEN enters. PAKIMI stands up abruptly and exits. HELEN sits beside CHIEF. They exit upstairs.

HELEN: (*Off. Authoritatively.*) Afolabi!

The End